Human Image

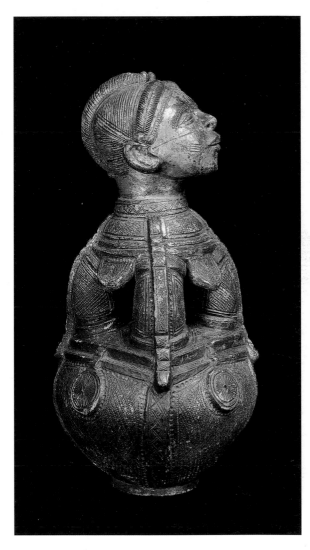

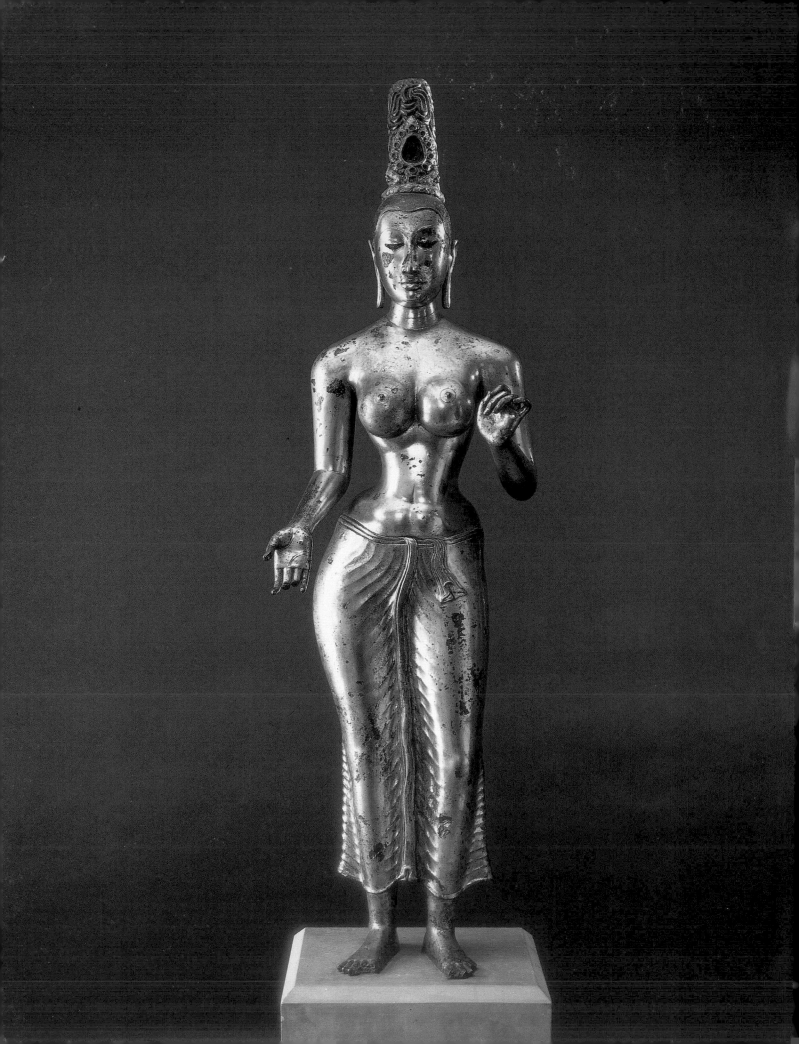

Edited by J.C.H. King

Human Image

THE BRITISH MUSEUM PRESS

The Trustees of the British Museum gratefully acknowledge the support of Linklaters towards the exhibition and the publication of this book.

First published in 2000 by British Museum Press
A division of The British Museum Company Ltd
46 Bloomsbury Street, London WC1B 3QQ

A catalogue record for this book is available from the British Library

ISBN 0 7141 2552 0

Designed by Harry Green
Typeset in Gill
Printed in Italy
by Grafiche Milani SpA, Milan

FRONT COVER AND HALF-TITLE PAGE

Water vessel with facial scarification
Made by Mbitim, Lurangu, Sudan, twentieth century
Terracotta, 32 cm
Water vessels of this kind were apparently devised to appeal to European tastes at the end of the nineteenth century. They are a testament to the Western interest in the human form as a privileged subject for artistic expression. This new tradition arose in a colonial context where (female) Mangbetu potters were intermarrying with (male) Zande potters for the first time. Such pots, then, involve the crossing of quite different cultural views of creativity and gender.

BACK COVER

Study for the Creation of Adam in the Sistine Chapel
by Michelangelo (1475–1564)
Italy, c. 1511
Drawing in red chalk, 19.3 x 25.9 cm
See fig. 21.

FRONTISPIECE

Tara
Found between Batticaloa and Trincomalee, Sri Lanka, eighth century AD
Gilded bronze, 1.43 m
Tara is the consort or 'wisdom partner' of the bodhisattva Avalokiteshvara, said to give him the strength to continue his effort to save suffering souls. Cast in solid bronze and mercury gilded, she represents the perfection of natural female beauty combined with deep spiritual dignity. She also represents the highest achievement of the ancient bronze casters and no comparable piece of this size is known from Sri Lanka.

Acknowledgements for quotations

p.12 *Popul Vuh. The Sacred Book of the Ancient Quiché Maya*, Norman (Oklahoma Press, 1950), p. 167.

p.18 'Manturai' from Tevaram text in *Poems to Siva: the Hymns of the Tamil Saints*, translated by Indira Viswanathan Peterson (New Jersey, 1989), pp. 162–3.

p.26 Robert Loder, Lisa Muncke and John Picton (eds), *Image and Form. Prints, drawings and sculpture from southern Africa and Nigeria* (London, 1997), p. 13.

p.34 Rowland Abiodun, Henry J. Drewal and John Pemberton III (eds), *The Yoruba Artist* (Washington, 1994), p. 127.

p.42 Winifred David recorded in the 1970s in 'Nu.tka. Captain Cook and the Spanish explorers', *Sound Heritage*, 7 (1), 1978.

p.50 Daniel David Luckenbill, *Ancient Records of Assyria and Babylonia Vol 1: Historical Records of Assyria from the earliest times to Sargon* (Chicago, 1926), p. 145.

p.58 *Hesperides* or *The Works both Humane and Divine of Robert Herrick Esq.* (London, 1648), pp. 307–8.

p.66 C. A. Turkington, *The Quotable Woman* (New York, 2000), p. 182.

p.74 Sir John Wyndham Pope-Hennessy, *Learning to Look* (London, 1991), p. 225.

p.82 Letter to Emile Bernard, Aix, 15 April 1904, in John Rewald (ed.), *Paul Cézanne: Letters* (London, 1941), no. 167, p. 234.

Acknowledgements

Numerous people helped compile this publication: all are to be warmly thanked, particularly Julia Walton, Lisa Voden-Decker, Phillip Taylor; Nigel Barley, Clara Bezanilla, Lissant Bolton, Jill Hasell, Julie Hudson, Chris Spring; Frances Carey, Sheila O'Connell; Sheila Canby, Jessica Harrison-Hall, Bob Knox, Jane Portal, Michael Willis; Aileen Dawson, Chris Entwistle, David Thompson; Julian Reade; Richard Parkinson, Jill Cook, Gillian Varndell; Virginia Hewitt, Venetia Porter, Luke Syson; Tim Clark, Victor Harris; Ian Jenkins; Laura Brockbank, Teresa Francis.

contents

Introduction 6

Creation 12

Devotion 18

Inscription 26

Perfection 34

Others 42

Power 50

Drapery 58

Guardians 66

Portraits 74

Abstraction 82

Object list 92

introduction

Images of the human form abound in museum collections. This is for the simple reason that in most cultures and at most times in history, men and women have created representations of themselves, or representations of other beings in human form. There have been many exhibitions in the past which have considered particular aspects of human representation but only a few have had the ambition to consider the broadest approaches, drawing together examples from different cultures and times in the past. The British Museum's earlier exhibition on a similar theme, *The Enduring Image*, shown in Delhi and Mumbai as a contribution to the celebrations marking India's fiftieth anniversary of Independence in 1997 and 1998, showed representations which were grouped by cultures corresponding to curatorial departments of the British Museum. *Human Image* is more ambitious and develops the theme further, deliberately juxtaposing images from different cultures, periods and themes to stimulate thoughts about the intentions of their makers and the use to which the objects were put. By these means analogies and contrasts (both expected and unforeseen) are revealed.

Up until the recent past, exhibitions tended to be heavily didactic: they had strong storylines and strong chronologies. Categorization and the development of typologies, whether from the natural or the artificial world, was an important purpose. Recently, especially in those new and yet to be characterized spaces created by museums at the end of the twenty-first century, there have been tendencies to experiment with the thematic exhibition. Though the Joseph Hotung Great Court Gallery is in the very heart of the Museum, it is insulated from those particularly powerful Smirkean spaces which surround it, the Egyptian Sculpture Gallery and the King's Library. It is an ideal site to try out ideas.

Human Image is loosely of the thematic genre of exhibition. It introduces, through ten elements or ideas, objects brought from the collections of the ten curatorial departments of the Museum. The elements which have emerged are

Creation, Devotion, Inscription, Perfection, Others, Power, Drapery, Guardians, Portraits and *Abstraction*. There is no traditional structure to the exhibition and the curator does not impose a view. The visitor is free to make whatever personal interpretations are stimulated by the objects displayed alongside one another. One general conclusion of visitors to the exhibition might be that though the themes seem disparate, and the cultures represented many and various, nonetheless the interconnectedness of ideas starts to become apparent. There has been some criticism of the new thematicism in UK museums and galleries, displacing chronology-based displays, but creators of temporary exhibitions should be open to incorporating the element of surprise, even shock. These exhibitions need to be different from the permanent presentation; thematic approaches are one way of challenging received understanding and provoking debate.

Images have been created for many purposes, though because of lack of other forms of evidence, it is frequently necessary to speculate just what these might have been, especially those from the distant past. Sculptured materials from the Upper Palaeolithic, the Old Stone Age, often show detailed female forms, while cave paintings offer only rare representations of men in addition to the predominant forms of animals. These could be said to confirm the enduring importance of fertility on the one hand and survival on the other. Creation-related images are to be found everywhere in religious iconography. Graphic and sculptural figures are frequently inspired by religious stories and texts.

Not all images immediately appear to be representational. Some of those of an abstract form from non-Western societies have actually acted as inspiration to Western artists. A striking example of this is the effect which Egyptian and African sculpture in the British Museum had on the young Henry Moore when he first came to London in the 1920s. African and early Iberian sculpture in the Musée d'Ethnographie du Trocadéro in Paris led Picasso to engage with primitivism. Representations of human or humanoid forms are not necessarily based

on direct evidence. There is a long tradition of creating pseudo-beings, where the imagination runs wild, especially when fear of the unknown is present. Some images combine human and animal forms, such as sphinxes and centaurs. Exaggerated features may be used to inspire fear or to ridicule. Throughout history, leaders have required powerful images of themselves to be produced, sometimes on a massive scale and in multiple versions, to drive home in an unambiguous manner the status quo. The fall of Communism in the Soviet Union and Eastern Europe led to the removal and mass-destruction of statues of former leaders; this has been newsworthy but is only one near-contemporary example. There has been a revival in China in the last decade of mass-producing small-scale images of Mao Zedong for sale as souvenirs.

Images are sometimes of the naked form but more frequently the body is clothed and sometimes bejewelled. Drapery in carved stone over the flesh was a virtuoso accomplishment of Greek sculptors and can be seen at its most dazzling on the fifth century BC pedimental figures from the Parthenon, and the somewhat later Nereid figures from Xanthos in the British Museum. On occasion, actual garments and real jewellery were applied to sculpture. Anachronistic clothing may be indicated; many a monarch or philosopher of the European Enlightenment was portrayed in classical dress. The body itself was sometimes decorated directly, and this is often to be seen in representations of such human figures. In certain societies and religions there is a prohibition on producing figurative images, in which case evidence may not be in the form of graphical or sculptural representation, but can be determined obliquely from other kinds of art form. Sometimes parts of the body, though not the face, may be shown. The earliest representations of the Buddha are not of his human form but of his swaddling-cloth or his footprints.

In contrast are representations which act as reminders of the actual likeness of a particular person, though inevitably having been interpreted by the

artist. Amongst the earliest two-dimensional examples are the mummy portraits from Graeco-Roman Egypt. It has been shown scientifically (where skulls as well as portraits survive) that the painted images are sometimes true individual portraits. This was not always the intention in devising an image. Sometimes perfection was pursued, with the ideal being represented rather than the actual. Alternatively, simplifying much of the figure can allow particular attributes to take on an exaggerated form, indicating clearly to the viewer the purpose of the representation. Caricatures can make bitter, deeply critical points.

Representations of the human figure can be devised or manipulated in a multiplicity of ways. From the earliest days of the public museum the intention was to categorize, by seeking similarities and pointing out contrasts. The ideal classical form was compared (favourably, it has to be said) with representations of the body from non-Western traditions. Yet it was the museums themselves which allowed the public to gain a broader view. As the van Rymsdyks stated in their early guide to the British Museum, it elevated their minds with 'great conceptions'. In fact, the British Museum, founded as it was on the encyclopaedic collection of Sir Hans Sloane (1660–1753), included the embryo ethnographic collection as well as the foundations of the soon-to-be unrivalled collection of classical antiquities. In the earliest days – indeed the early years – of the nineteenth century it was not easy for the ordinary public (as opposed to gentlefolk) to gain access to the collection. In part, this was due to the inadequacies of the building. Montagu House, a mansion first constructed in 1675, was conveniently available when the first trustees sought accommodation in 1753. It was a crisis of space caused by the rapidly expanding collection in the early nineteenth century which led the Government to employ Robert Smirke to design something more adequate and appropriate.

Smirke's 1823 concept was that of an expanded Greek temple, which provided good correspondence between the collection as it then was (the

Parthenon sculptures had come in 1816) and the building that was to house it. The classical forms contained within provided much inspiration to artists of the day. Collecting was not only active at Greek and Roman sites: expeditions were supported in Egypt and the Ancient Near East which filled galleries as soon as Smirke provided them. But even this activity was deemed inadequately comprehensive in the mid-nineteenth century and Augustus Wollaston Franks, perhaps the British Museum's greatest curator ever, was detailed to improve the Medieval, Renaissance, Oriental and Ethnographic collections. He succeeded to great effect, and the fact that the British Museum is able to devise *Human Image* entirely from its own resources is largely due to Franks' effectiveness. The rapidly increasing collections, however, made it difficult to manage and the natural history specimens left for their South Kensington home in 1880. At about the same time the National Portrait Gallery was offered the British Museum's collection of portraits on canvas. The 'foreigners' and those on paper remained at Bloomsbury.

The concept of the special, or temporary exhibition, is a relatively recent one. Though the genre can be traced in the British Museum back to the last part of the nineteenth century, early manifestations were modest. The 'blockbuster' exhibition did not arrive until 1972, with *The Treasures of Tutankhamun* being displayed in a conveniently available gallery which had recently been vacated. A particular problem which has had to be faced by many museums which were built before the advent of large ambitious exhibitions has been that the original galleries do not incorporate the specialized arrangements which are now routinely needed. The British Museum did not get its first exhibition gallery until the 1970s, when the architect Colin St John Wilson designed one for the New Wing. When it was known that the British Library would be leaving Bloomsbury and that the Museum would be able to occupy the space it formerly occupied, it was clear that one requirement should be that an additional gallery be requested of the architects of the Great Court, Foster and Partners. *Human Image* is the first

exhibition to take place in that gallery, opened as part of the Great Court on 6 December 2000.

Human Image draws the collections of the British Museum together. Each of the ten curatorial departments has contributed to a common purpose in the exhibition, that of considering how the many ways of representing the form of man offer a deeper understanding of our cultural past throughout the world. This exhibition, when considered with two important developments, the return of the Department of Ethnography from Burlington Gardens (where for thirty years it was exiled from Bloomsbury as the Museum of Mankind), and the setting up of the Study Centre (due to be fully operational in 2004), will indicate even more clearly the potential which is locked in the riches of one of the world's greatest museums.

Human Image has been devised by Jonathan King of the Department of Ethnography, assisted by Julia Walton. The earlier concept, *The Enduring Image*, was curated by Richard Blurton of the Department of Oriental Antiquities. All curatorial departments of the British Museum have contributed objects and expertise, the Conservation and Exhibition departments also playing major roles. The British Museum is indebted to the generosity of one of its Trustees, Sir Joseph Hotung, who sponsored the new gallery, known as the Joseph Hotung Great Court Gallery. It is available for the very first time for *Human Image*.

I wish to express the grateful thanks of the British Museum to the generous sponsors of this exhibition, Linklaters.

Robert Anderson
Director
BRITISH MUSEUM

'Grinding the yellow maize and the white maize Xmucané [grandmother creator] made nine drinks, and from this food came the strength and the flesh, and with it they had created the muscles and the strength of man . . .'

Anon, Quiché Maya text, Guatemala, sixteenth century

creation

Ideas of creation and fertility may be personified and represented by both male and female forms. Images of women and their children predominate during the earliest civilizations in Europe, which indicates the importance placed on fecundity and motherhood. Sculptural figures often exaggerate femininity, while two-dimensional representations tend to be far more abstract. The use of male forms to convey fertility, later starkly illustrated by the figurine of the Roman god Priapus (fig. 3), is less common.

Christianity adopted and developed the most potent image of mother and child in the West – the Virgin Mary and infant Christ – as in the Raphael cartoon (fig. 5). The veneration of such images may be inspired by the identification with this essentially human act of creation, balanced against the pair's obvious divine superiority. But the mother and child as a powerful symbol is universal: in Africa, stylized figures, such as that from the Idoma of Nigeria (fig. 4), express similar moral values.

In hunting societies images of creativity often relate to animals. In particularly they signify the religious element of the hunter's relationship to them, a form of spiritual husbandry. This ensures the survival, reproduction and availability of the species on whom people depend.

Vital to many societies is the personification of creative beings and muses, who may be worshipped and beseeched, for instance the Maya maize god from Honduras (fig. 2). Another example is the Polynesian figure of the deity A'a (fig. 1), who may at one time have also been associated with the creator god Tangaroa. Originally the hollow interior was filled with newly generated offspring of the type seen on the parent figure's surface.

1 Polynesian hardwood figure known as A'a
Rurutu, Austral Islands, late eighteenth century
Wood, 117 cm
This figure depicts a Rurutan god, A'a, in the process of creating other gods and men: his creations cover the surface of his body as thirty small figures. A removable panel at the back reveals a cavity which originally contained twenty-four further small figures, since destroyed.

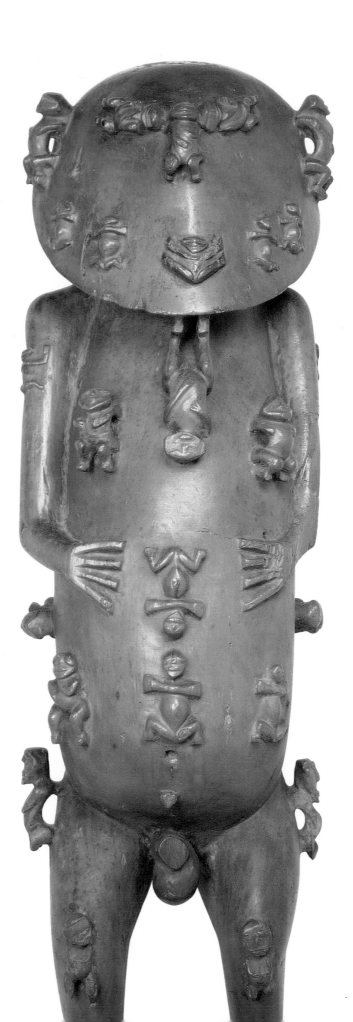

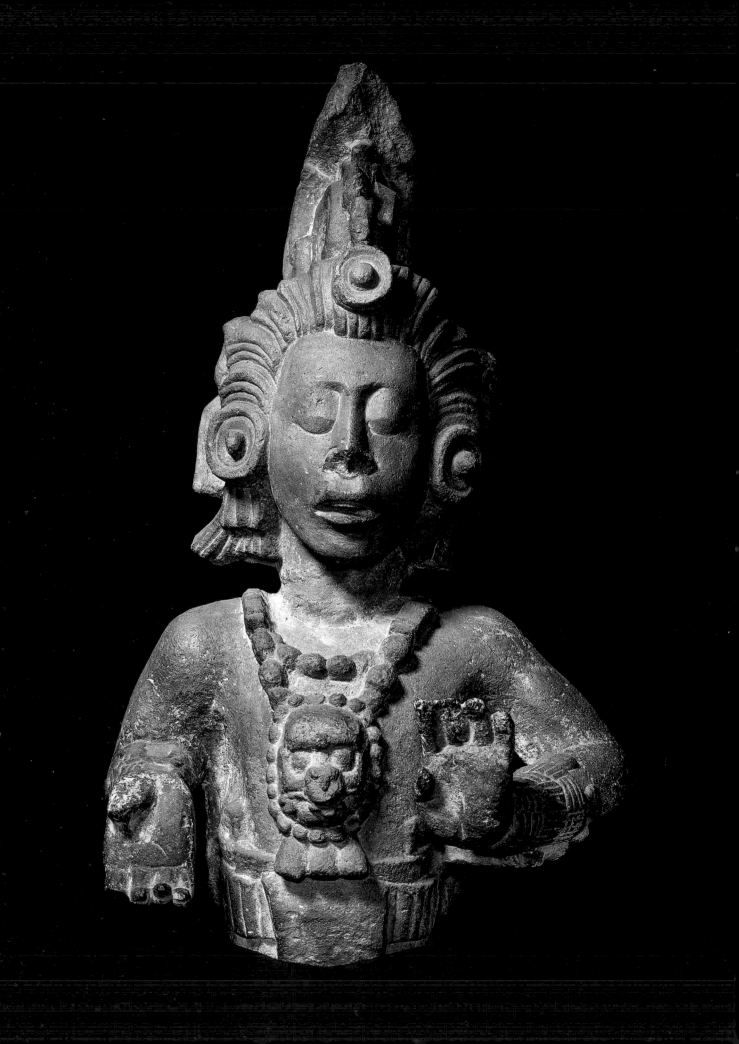

◁ **2 Maize god**
Maya [Structure 22, Copan], Honduras,
Classic period (AD 250–900)
Stone, 90 cm
The Maize god personifies the agricultural
cycle and is associated with abundance and
prosperity. Maize was the ingredient used by
the gods to fashion sentient beings. According
to the *Popol Vuh*, the sacred book of the
Quiché Maya, the gods created humans out of
yellow and white maize, following
unsuccessful attempts with mud and wood.

3 Priapus
Pakenham, Suffolk, first century AD
Bronze, 8.4 cm
The ithyphallic god Priapus promoted
the fertility of fields and gardens and
protected territory.

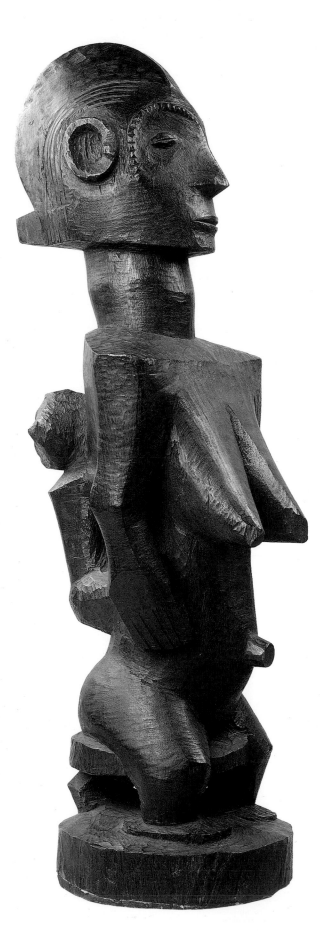

**4 Carved figure
of mother and child**
Idoma, Nigeria, twentieth
century
Wood, 30 cm
In African sculpture the
relationship between a child
and its mother may often be
used to represent other
relations, even those of a
purely political nature.

5 *The Virgin and Child* **by Raphael
(1483–1520)**
Italy, c. 1512–14
Drawing in black chalk, 70.7 x 53.3 cm
This is a cartoon for the painting
known as 'The Mackintosh Madonna'
in the National Gallery. It was made
during the period when Raphael was
playing a major role in the
redecoration of the Vatican. The strong
link between mother and child is
emphasized in this study for a
Christian devotional image.

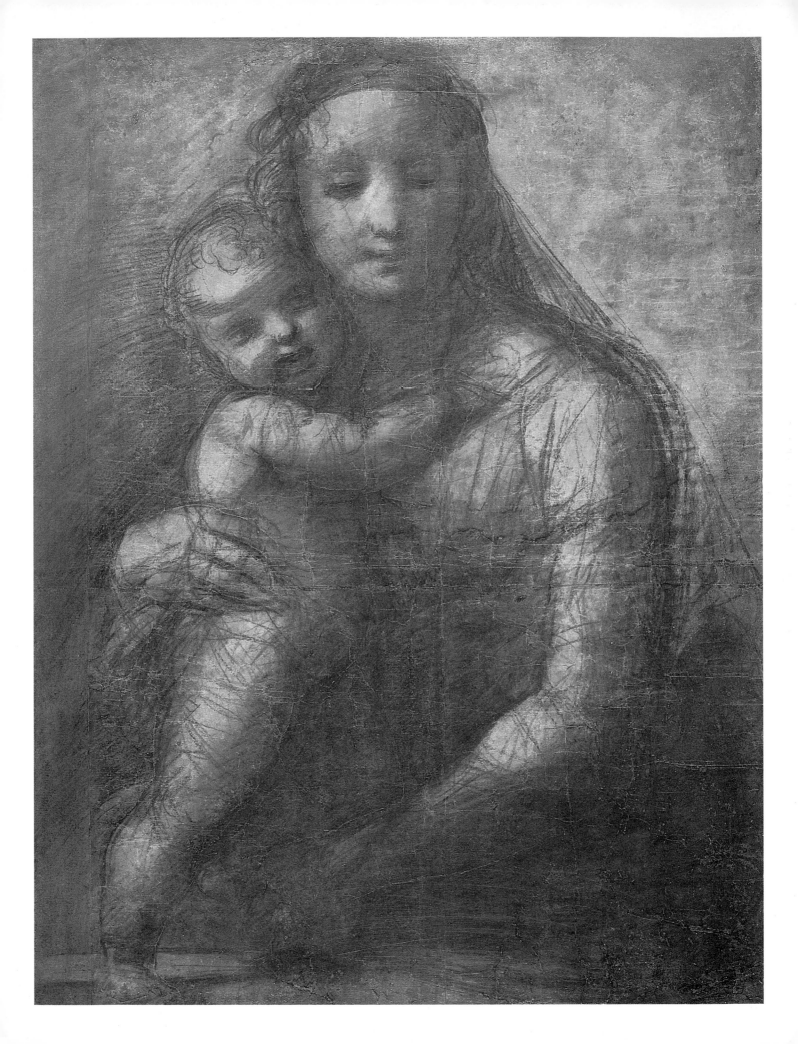

'Let us praise the tender feet

worshipped by the gods

the feet of our Lord who dwells in *Manturai*

on the northern bank of the *Kaveri*

which flows like a stream of gold,

bearing the blossoms of the golden *venkai*.'

Sambanda (Campantar), author-saint (570–670 AD), 'Manturai'

devotion

Religions transcend cultural foundations and promote universal beliefs. At the same time, within individual religions, beliefs and rituals may change in response to different traditions and people. The artistic expression of devotion therefore acts as a fundamental marker of social and cultural identity.

Religions provide a variety of representations of deities, saints or devotional figures, such as the Gothic figure of the Virgin and Child from fourteenth-century Paris (fig. 12), and from Japan the twelfth-century figure of Fudo-Myō-Ō, the wooden sculpture of a Buddhist deity (fig. 13). Many enigmatic ancient objects, such as the British Neolithic limestone 'drum' from Folkton (fig. 10) that seems to be carved with human facial features, may have originally possessed a ritual aspect.

Devotional figures are usually created for religious settings, like the head reliquary of the Roman martyr St Eustace, from the Cathedral Treasury of Basle (fig. 6). Alternatively they may be made to be worn, like the Mexican mosaic-covered skull of Tezcatlipoca ('Smoking Mirror'), associated with war and creation (fig. 11). Aztec religion has been mistakenly associated with an undocumented rock-crystal skull (fig. 7) which has become a focus for contemporary mysticism

Participation in religion requires careful preparation, through prayer or in altering the state of mind and body. This may be accomplished by fasting, ascetic practices, or through the limited use of narcotics such as tobacco. Shamanism – possession by an animal or non-human spirit – is also transformational; it is represented here by a Yup'ik figure from Alaska (fig. 9). Spiritual transcendence is indicated in the Taino figure from Jamaica (fig. 8), weeping to provide the tears that water the earth.

6 Reliquary of St Eustace
Basle, Switzerland, c. 1210
Gem-set silver-gilt, silver,
wood, 32 cm
The wooden core contained
a parcel of relics, including
fragments of the skull of
St Eustace which inspired the
shape of the reliquary. The
core was originally concealed
inside the silver version but
is now shown separately.

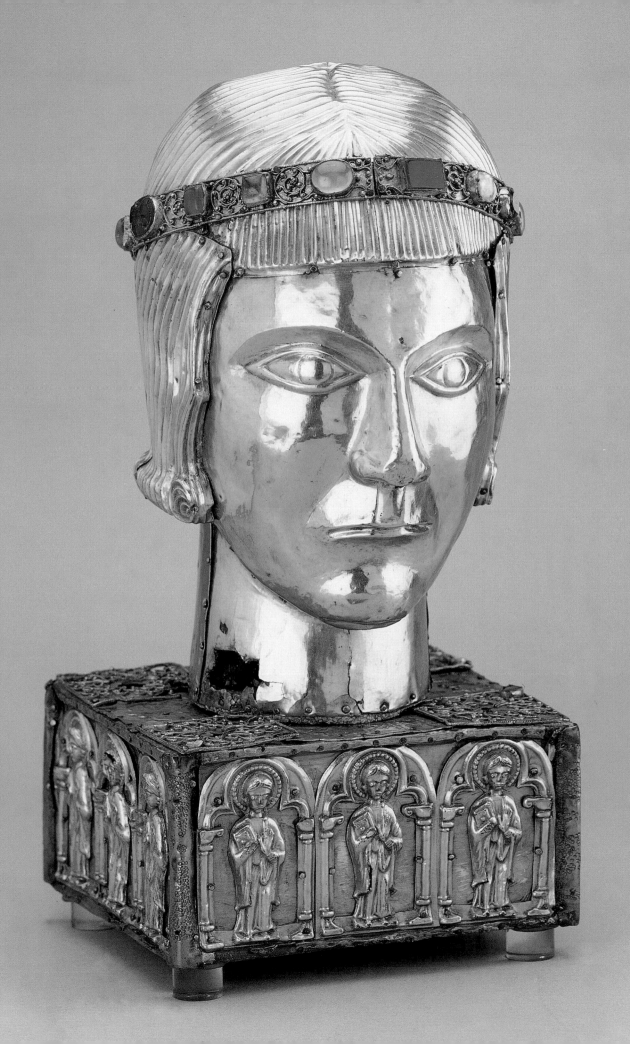

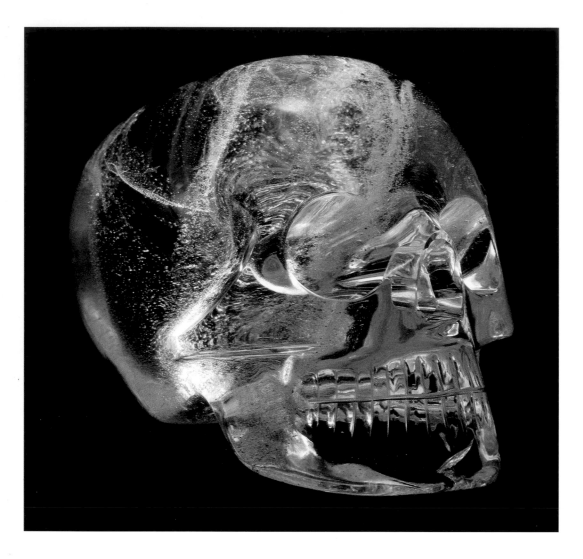

◁ **7 Crystal skull**
Probably European,
nineteenth century
Rock-crystal, 25 cm
Mystical powers are often
attributed to objects fashioned
in rock-crystal. Although once
thought to be Mexican, traces
of the use of a jeweller's wheel
and the highly polished surface
on this example indicate that
it was made well after
European contact, probably in
the late nineteenth century.

8 Zemí
Taíno, Jamaica, AD 1200–1500
Wood and shell, 100 cm
This *zemí* has been identified
with Boinayel, the Rain Giver,
whose tears provide the rain to
nourish the earth. The *zemís*
were perceived as a connection
between the spirit world of
humans and nature. Only
shamans and chiefs had the
required knowledge to
interpret their 'sacred language'.
This revered object was found
hidden in a cave in the
Carpenters Mountains, in 1792.

◁ **9 *Tuunraq* figure
(spirit helper to a shaman),
perhaps used as a drum handle**
Yup'ik, Alaska, nineteenth century
Wood, sinew, fox teeth, 30 cm
Predatory carnivorous creatures
of the other world are depicted
on ritual equipment by Alaskan Yuiit.
They are shown with fearsome
mouths, in the body as well as the
head. Masks with large mouths are
also related to a deformed creature
called Hammer Child who may
consume people who break taboos.

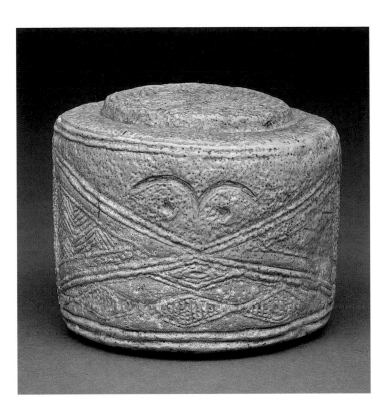

10 Folkton 'drum'
Folkton, East Yorkshire, England,
Late Neolithic, c. 2600–2000 BC
Magnesian limestone, 8.7 x 10.4 cm
One of three solid cylinders found with
an adolescent skeleton in a grave beneath
a round barrow. These unique objects are
elaborately carved using motifs drawn
from a pool of designs current during the
third millennium BC. The eye-and-eyebrow
motif (if indeed it was intended as such)
is an exception; it appears to break a
tradition in the British Neolithic where
the human face is not portrayed.

11 Mask of Tezcatlipoca
Mixtec-Aztec, Mexico, AD 1400–1521
Turquoise and lignite mosaic over a human
skull; iron pyrite, shell, leather, 20 cm
This mask, which may have been worn by
a priest, is believed to represent the god
Tezcatlipoca, one of the Aztec creator gods.

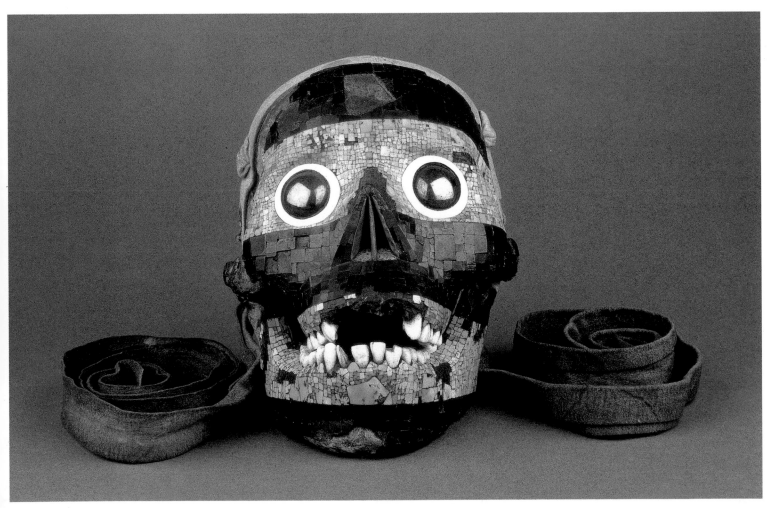

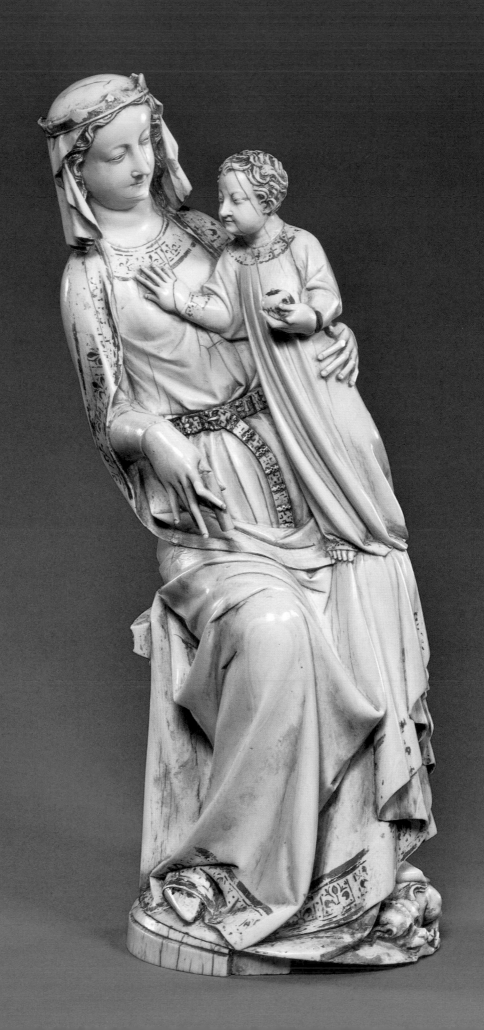

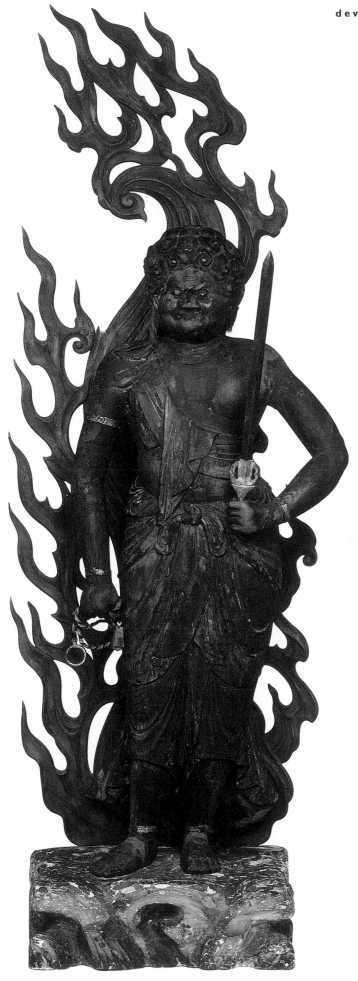

◁ **12 Virgin and Child**
Paris, France, 1320–30
Elephant ivory, 33.5 cm
The curve of the elephant's tusk
heightens the fashionable sway of
the figures. The devil, in the form of
a dragon, is trampled underfoot.

13 Fudo Myō-Ō
Japan, Heian period,
late twelfth century
Wood, 144 cm
This Buddhist deity is the foremost
of the five 'Kings of Light' of the
esoteric Shingon sect. His fierce
aspect indicates his intolerance of
wickedness. Fudo's name means
'Unmoving', implying unchanging
reality beyond the illusion of life,
death and the terrible flames
amidst which he stands.

inscription

Most facial and body decoration is temporary, whether in the form of cosmetics or paint, or in the use of jewellery. It can also be permanent, through use of tattoos, lip plugs, or artificial constriction of the developing body. These techniques are perceived as enhancing beauty and confirming social status. For instance, the markings on the Bena Lulua figure (fig. 18) proclaim a sense of central African aesthetics, as does the Zande pot from Sudan illustrated on the cover. Without decoration or adaptation of the body, people can feel naked and unadorned or excluded.

Decoration may advertise people's social position and origins: for example, the Haida mask of the female ancestor Djiláquons (fig. 14) proclaims the high status of this Native American through the lip plug. The wrestler in the nineteenth-century Japanese print (fig. 17) is immediately recognizable as Chinese by the peonies and lion cubs prominent among his tattoos. The tattoos on the Greek terracotta (fig. 20) indicate that she is a captured Thracian and probably a performer in bawdy entertainments. In the sixteenth century, John White painted an imaginative watercolour of an early Pictish man, with body decoration in the form of Renaissance armour (fig. 19).

Statues, wall paintings and ceramics may literally be inscribed with text to enhance and explain the purpose of the image. Here the black limestone *kudurru* or boundary stone of Marduk-nadin-ahhe (fig. 15) is inscribed with the text of a land-deal which the carving of the king helps to validate. In some religions such as Islam and Judaism, the depiction of the deity may be forbidden and the written word used to express God's glory.

14 Mask of a woman of high rank, with labret and painted crest design
Haida, British Columbia, *c.* 1830; alder wood and pigment, 23 cm
Explorers such as Captain George Vancouver, in the 1790s, noted the authority of women who wore these plugs in the lower lip. As leaders in matrilineal societies they would stand up in canoes and eloquently greet the strangers. While Europeans neither understood the speeches, nor comprehended the unusually high status of women, they avidly collected labrets, as well as masks of this type, which may represent a prominent ancestor Djiláquons.

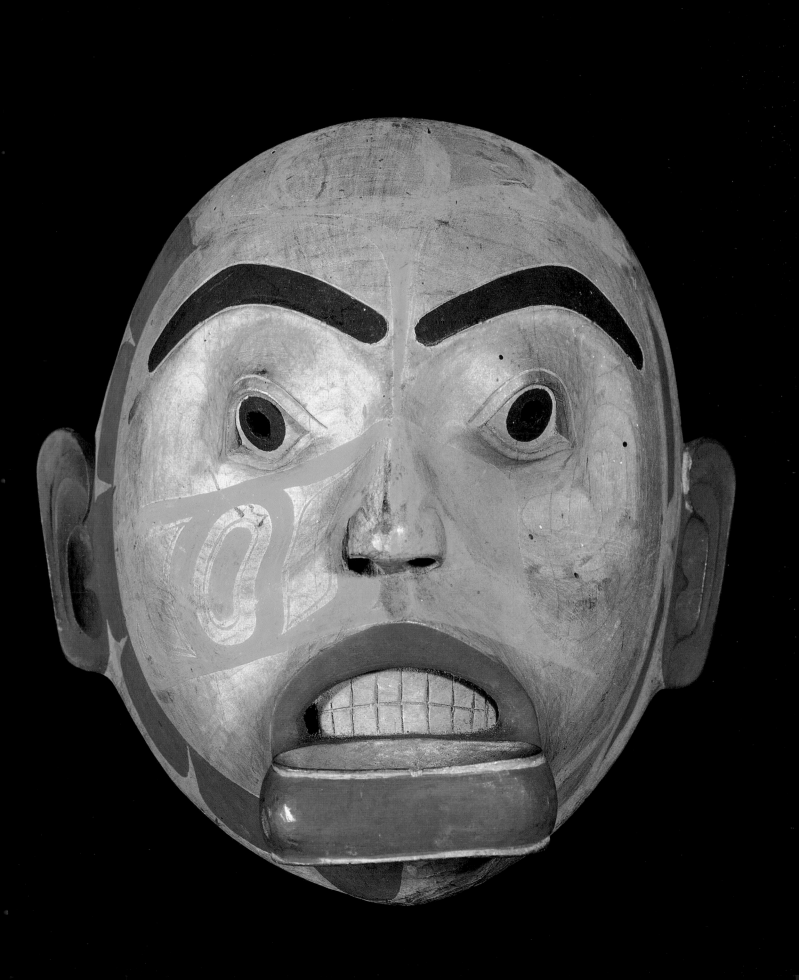

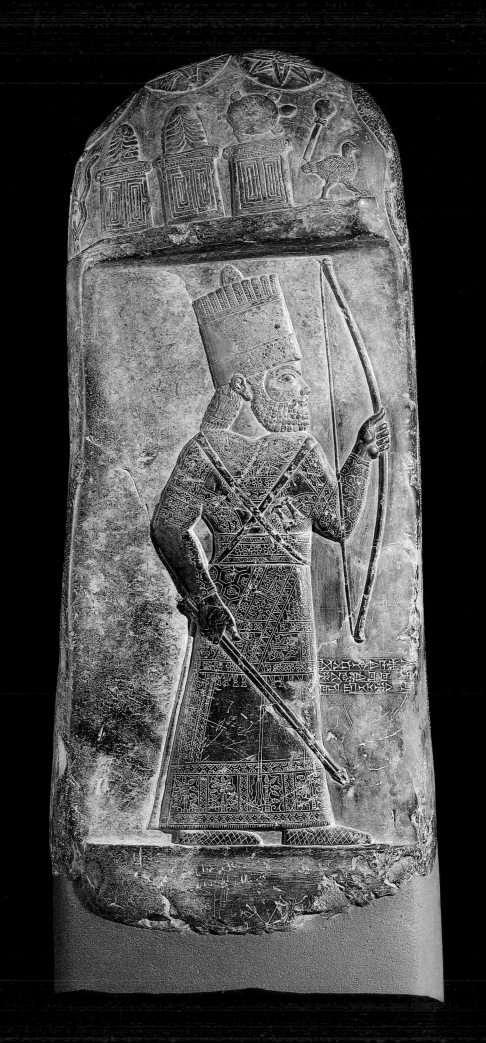

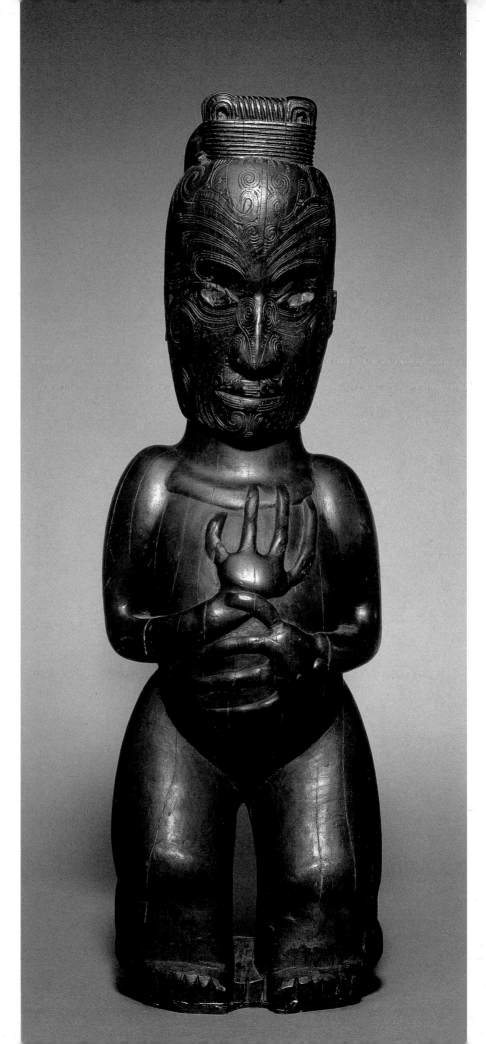

◁ **15** *Kudurru* **of Marduk-nadin-ahhe**
Babylon, Iraq, *c.* 1090 BC
Black limestone, 61 cm
This stone was the permanent record of an
important land sale, and was preserved in the
temple of the sun, god of justice. The human
figure is the king of Babylon, in ceremonial
dress, the embodiment of authority. The details
of the sale were written on the back, and
beside the king is the name given to the stone
itself: 'Establisher of the Boundary forever'.

16 Male figure
New Zealand, mid-nineteenth century
Wood, 85 cm
This figure, carved at the base of the interior
central post of a meeting house, represents
an important ancestor of the tribal group
which owned the house. It is carved in a
naturalistic style, with detailed male facial
tattoos and the hair wound up in a topknot.

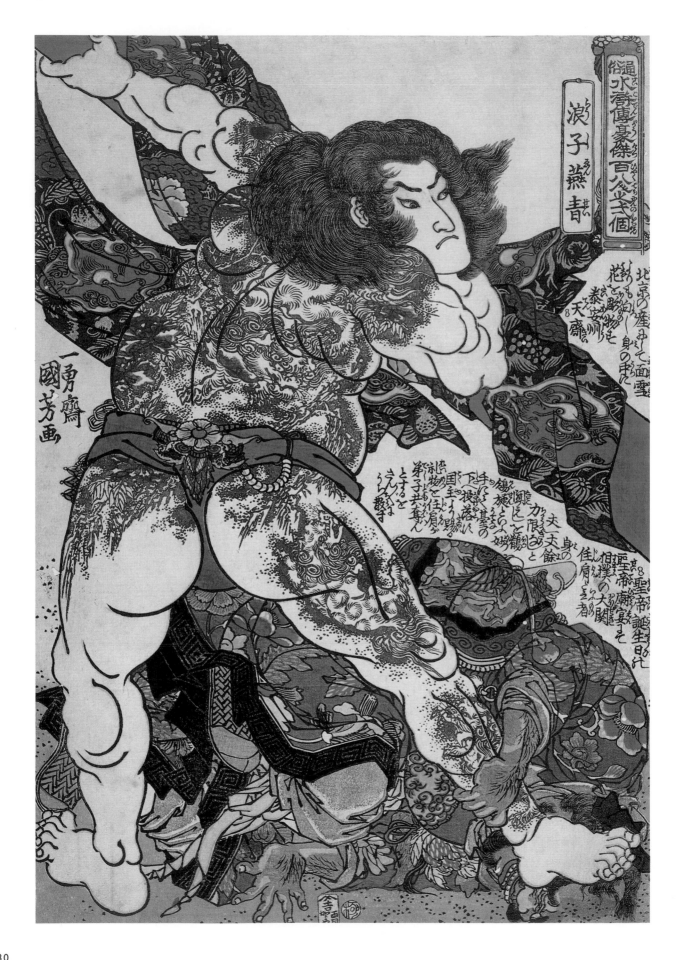

◁ **17 *The Wrestler Roshi
Ensei* by Utagawa
Kuniyoshi (1797–1861)**
Japan, *c.* 1827–30
Colour woodblock print,
56 x 40.5 cm
This popular Japanese colour
print by Kuniyoshi depicts
one of the 108 heroes of the
Chinese adventure story
Shuihu zhuan ('The Water
Margin'), which was
sensationally popular in a
translation that appeared in
Japan in the early decades of
the nineteenth century.
Ensei's snow-white body was
decorated at an early age by
a master tattoo artist with an
elaborate, all-body design of
peonies and Chinese *shishi*.

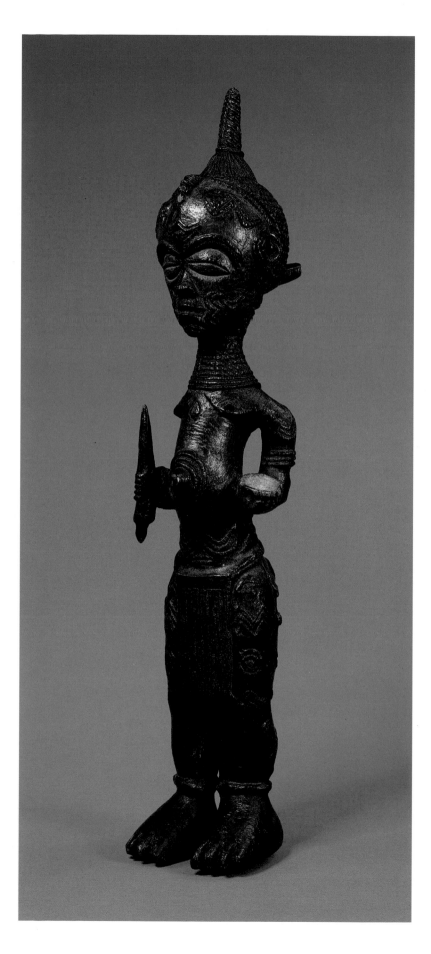

**18 Bena Lulua
ancestor figure**
Democratic Republic of
Congo, twentieth century
Wood, 42 cm
This carved figure shows
a style of scarification,
abandoned in the nineteenth
century, closely associated
with ancestors. The
scarification, coiffure and
style of dress of the figure
indicate a man of the highest
initiatory rank of the cult
mnkashama or 'leopard'.

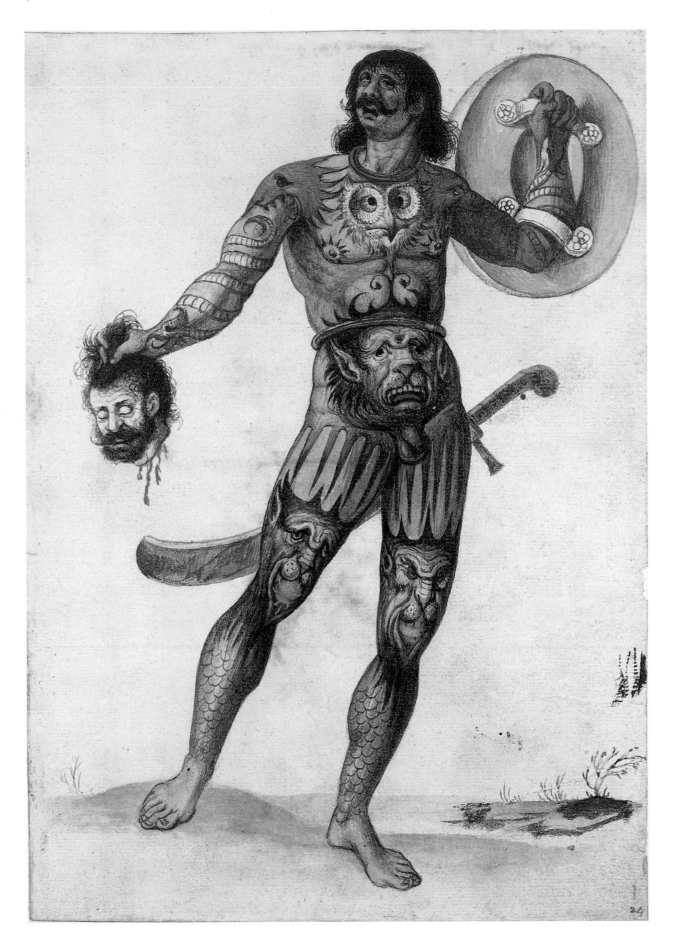

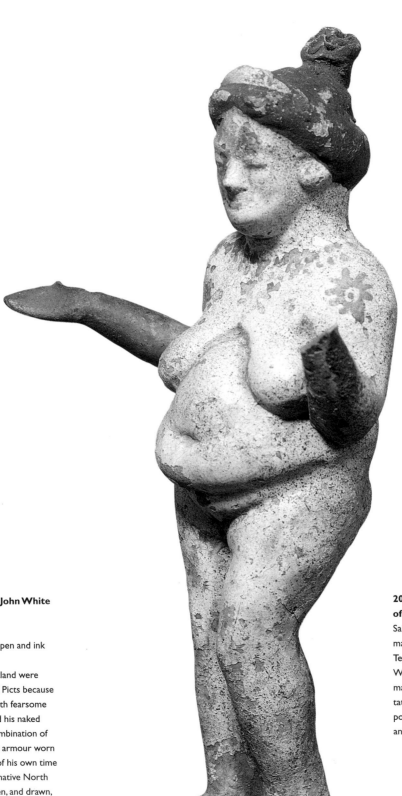

◁ **19 *A Pictish warrior* by John White
(active c. 1575–93)**
Britain, c. 1590
Drawing in watercolour and pen and ink
over graphite, 24.5 x 17 cm
The warriors of ancient Scotland were
thought to have been named Picts because
their bodies were painted with fearsome
images. John White has based his naked
warrior's body paint on a combination of
elements from the elaborate armour worn
at the courtly tournaments of his own time
and from the tattoos of the native North
Americans whom he had seen, and drawn,
on voyages to the New World during the
previous decade.

**20 Grotesque figure
of a tattooed woman**
Said to be from Tanagra in Boeotia,
mainland Greece, c. 350–290 BC
Terracotta, 18.2 cm
Women from Thrace to the north of
mainland Greece are often shown with
tattoos in Greek art. This is perhaps a
portrayal of a Thracian slave, possibly
an entertainer dancing burlesques.

'He carved the wood, and it was perfect.

The wood had eyes, a mouth, and a powerful chest.'

From the *oriki* [praise poetry] for Taiwo, Nigeria (*c.* 1855–1935)

perfection

In ancient Greece, sculptors perfected their notion of the ideal face and body. Later artists were inspired by these classical works of art, such as the Discobolos by the Greek sculptor Myron, various Roman copies of which were rediscovered from the sixteenth century onwards (fig. 25).

In the Renaissance, mathematical ideas of proportion and ratio derived from classical precepts were used to ensure harmony and symmetry in the representation of figures. Michelangelo's figure of *Adam* (fig. 21), a drawing from about 1511, illustrates the idealization of the human form. An alternative, from northern Europe, is the depiction of human proportion in Albrecht Dürer's drawing of *Apollo and Diana* (fig. 24). Ideal representations of individuals feature on coins, miniature portraits, and on maiolica dishes, such as that labelled 'Divine and beautiful Lucia' of 1524 (fig. 23). Such dishes were probably love gifts, commissioned by admirers for presentation to the object of their affection.

Concepts of spiritual and physical perfection may of course be culturally specific, as well as universal. In Africa, as elsewhere, the aesthetics of the body and sculpture express moral ideas. Hard work, civilization and honour are demonstrated by appropriate attributes, particularly the emphasis on musculature as demonstrated by the Benin and Ibibio figures from Nigeria (fig. 26, 27).

The eleventh-century figure of a Hindu goddess from Rajasthan (fig. 22) is apparently sensuous but more appropriately understood as a stereotyped representation of fertility and perfection. The twentieth-century artist Jacob Epstein kept this figure in his studio as a model of beauty and source of inspiration. The tenth-century Sri Lankan sculpture of the goddess Tara shown at the beginning of the book is a supreme example of Buddhist ideas of divine perfection.

21 *Study for the Creation of Adam in the Sistine Chapel* by Michelangelo (1475–1564)
Italy, *c.* 1511
Drawing in red chalk, 19.3 x 25.9 cm
This drawing is a study for the famous figure of Adam in 'The Creation of Man' on the ceiling of the Sistine Chapel. Michelangelo's drawings have always been admired and used as inspiration by other artists; this drawing passed through the collections of three British artists, Jonathan Richardson, Joshua Reynolds and Thomas Lawrence.

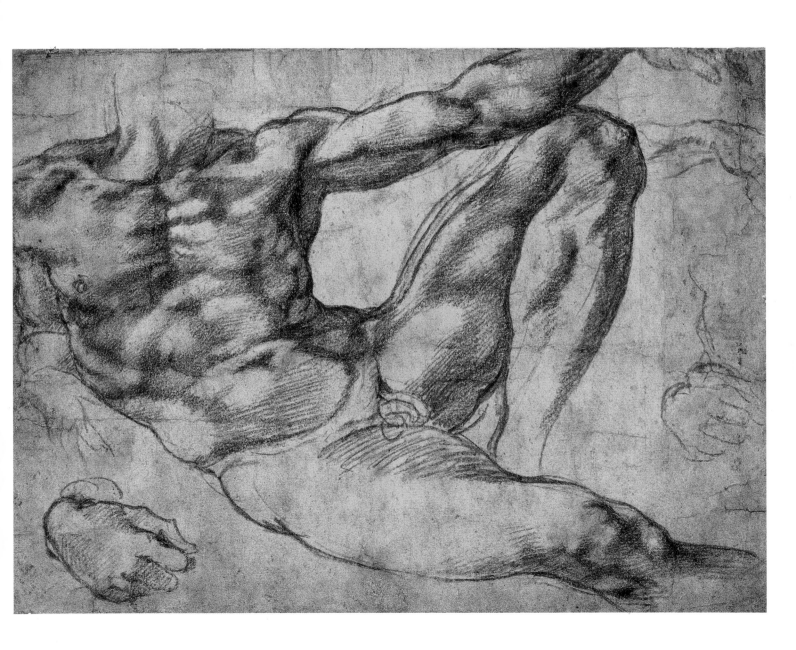

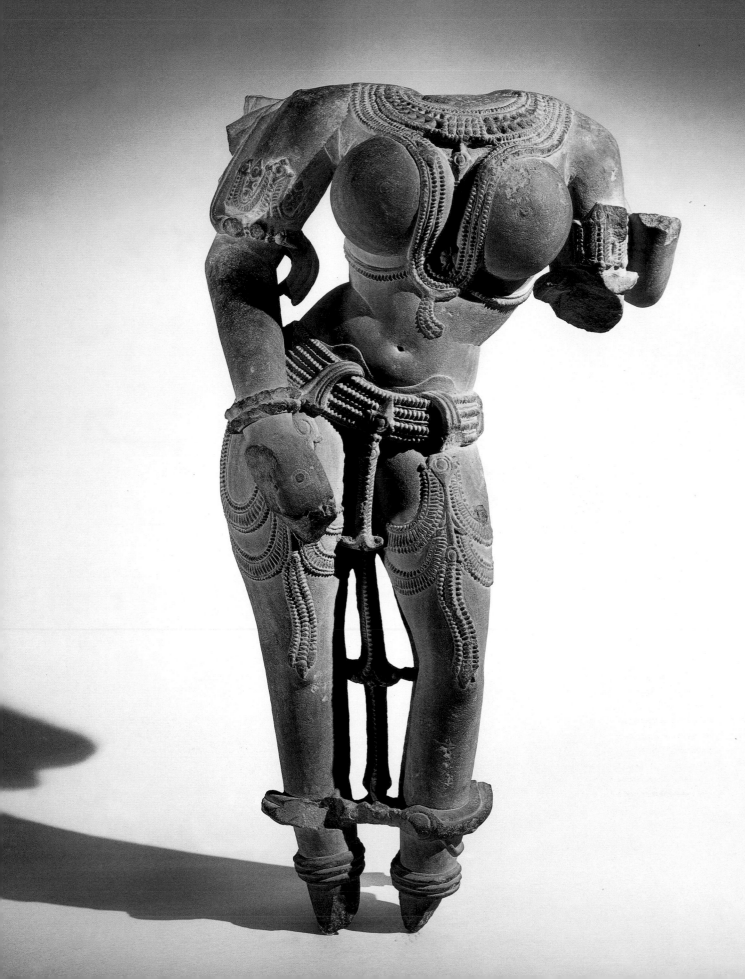

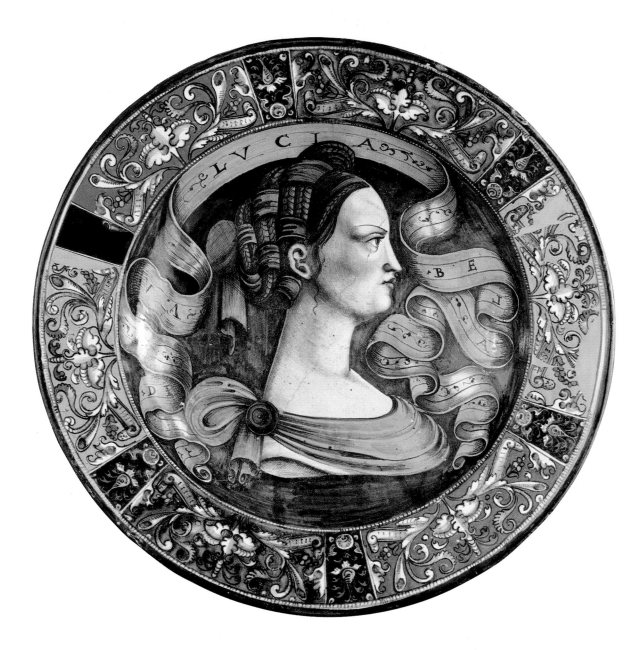

◁ **22 Hindu goddess**

Possibly from Rajasthan, India, eleventh century AD
Sandstone, 76 cm
This multi-armed, standing goddess is a temple
image, once worshipped in the context of what
may have been a great religious building.
The angular style, exaggerated proportions and
colour of the sandstone suggest this piece was
carved in western India.

23 Dish with female head

Umbria, Italy, dated 1524
Tin-glazed earthenware, diam. 43 cm
Maiolica became a medium for figurative painting
in Renaissance Italy. This idealized head conforms
to the contemporary notions of beauty while
the label translates as 'Divine and beautiful Lucia'.

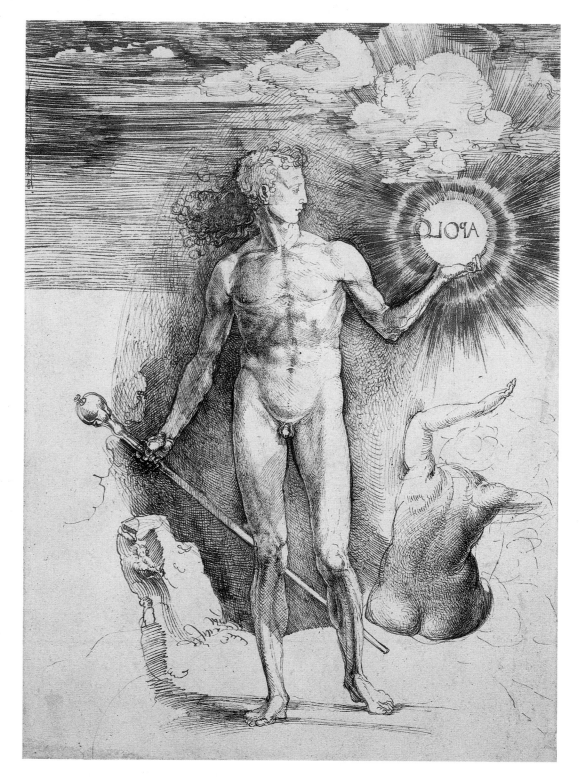

24 *Apollo and Diana*
by Albrecht Dürer
(1471–1528)
Germany, 1501–5
Pen and ink drawing,
28.3 x 20.5 cm
The figure of Apollo in this
drawing is one of the first
of Dürer's studies of the
proportions of the male
body. The development
of a system of human
proportions was to fascinate
him throughout his life.
The Apollo is based on the
then recently discovered
classical sculpture, later
known as the 'Apollo
Belvedere', which Dürer
would have known from
engravings.

25 Discus-thrower
(*Discobolos*)
From Hadrian's Villa at Tivoli,
Italy, *c.* AD 120–140
Marble, 170 cm
Made to be viewed from one
side only, the discus-thrower
is a highly compressed study
of the action of the athlete.
It was not intended to
capture any single moment
in the throw. Rather it aims
to present the concentrated
essence of the athlete's action
in a pose that both displays
and defines his movement.

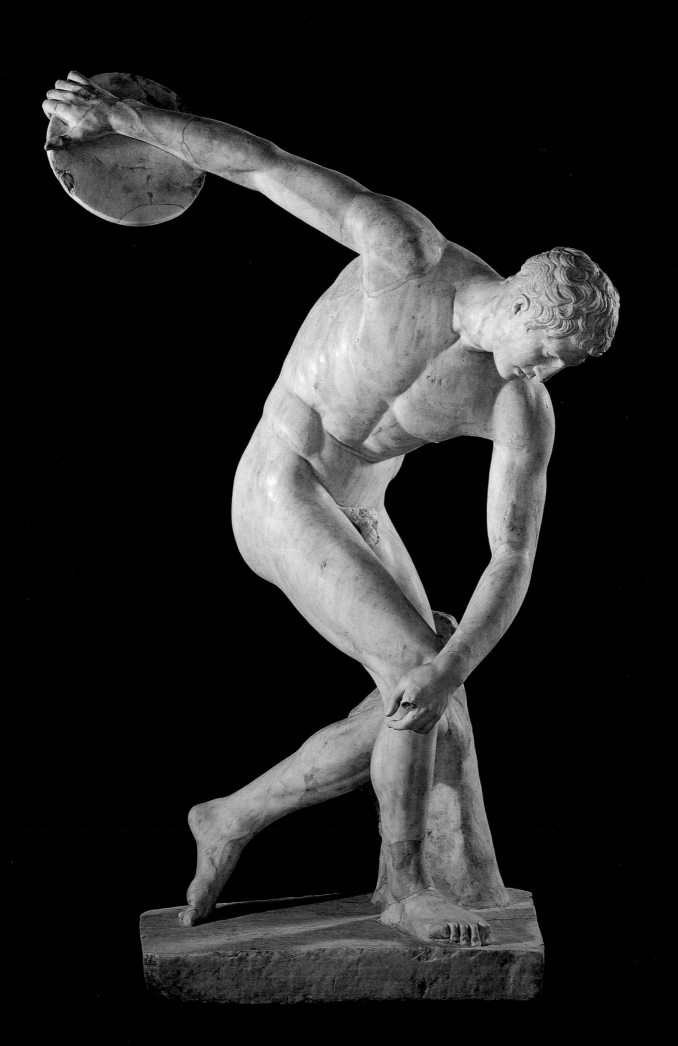

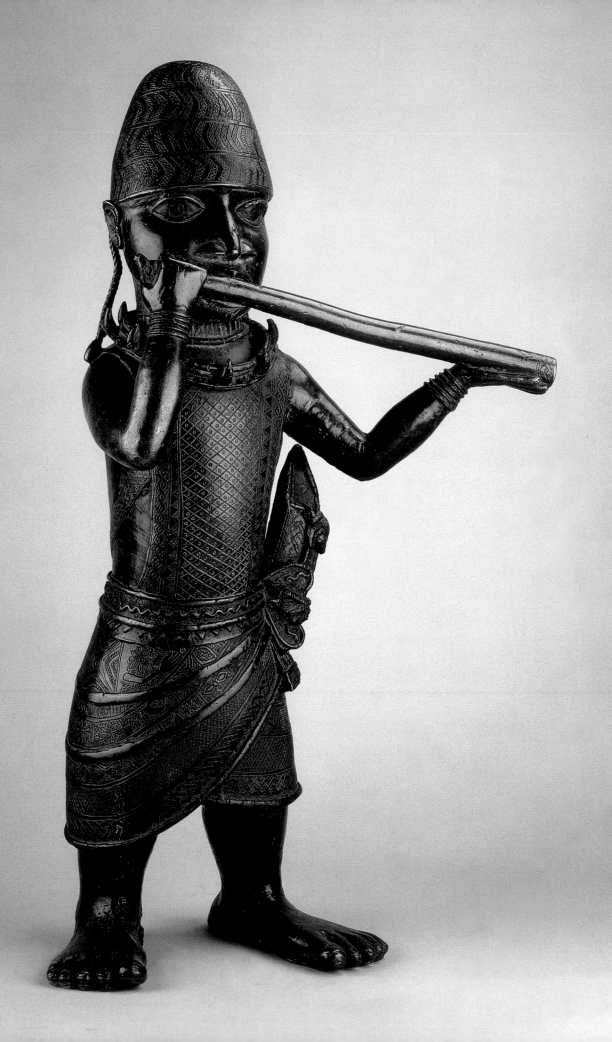

◁ **26 Cast figure of a horn player**
Benin, Nigeria, sixteenth century
Brass, 62 cm
Although Benin art is known for its extreme
naturalism, it follows the normal African
principles of greatly elongating the head with
respect to the rest of the body, thus reflecting
its social and cultural importance.

27 Ibibio figure from the Ekkpo society
Old Calabar, Nigeria, nineteenth century
Wood, 180 cm
This expressive figure incorporates filed teeth,
bracelets and raised facial scars. The black and
white markings are elaborate body painting.
Both the scarification and body paint
demonstrate a pervasive African idea that the
natural human body is incomplete and requires
modification to attain perfection.

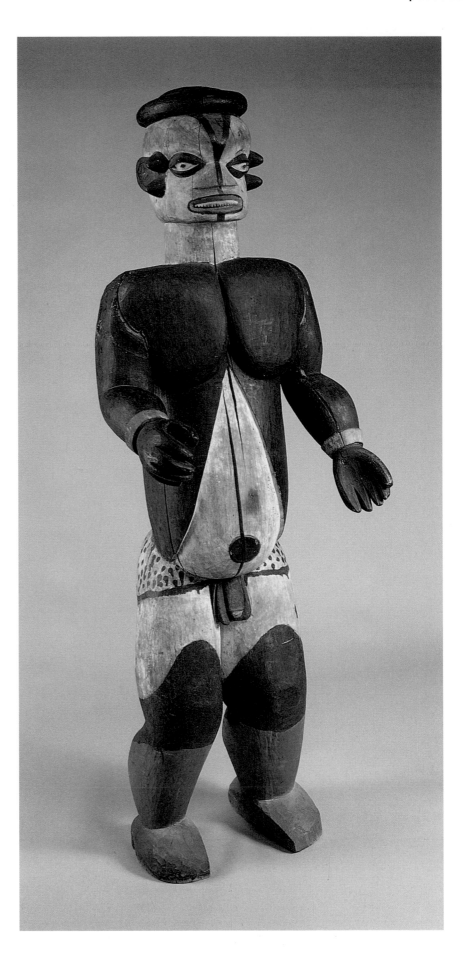

'The Indians didn't know what on earth it was when his [Captain Cook's] ship came in to the harbour… they thought it was a fish come alive into people. One white man had a real hooked nose. …And one of the men was saying… "See, see… he must have been a dog salmon, that guy there he's got a hooked nose." …The other one said "Yes! We're right, we're right. Those people, they must have been fish."'

Mowachaht account of the arrival of Captain James Cook off Vancouver Island, 1778

Artists have always depicted other people and outsiders, creating images which are used to define self and community. For example, the Haida figure of a large European woman with a diminutive man attached (fig. 28) may express a Native North American view of European relations between the genders. Two Chinese views of Pacific Islanders, separated by nearly a thousand years, also illustrate others: an oil painting of visitors to China in 1791 (fig. 35), and a Tang funerary figure of a pearl diver (fig. 34). A redefinition of familiar European images may occur in other cultures. Both a sixteenth-century African salt cellar (fig. 32) and an eighteenth-century Chinese porcelain figure (fig. 31) incorporate non-European interpretations of the Virgin Mary.

Caricature is mistakenly assumed by some to be a Western European development. Yet it is matched by Japanese artists in humour, as in the eighteenth-century toggle, or *netsuke*, of a Dutchman, who is making a Japanese derisory gesture by pulling down one eyelid (fig. 33); and the scroll of Diogenes the Greek Cynic philosopher, in his barrel, by Shimomura Kanzan (fig. 29).

European exploration and trade during the sixteenth century stimulated an interest in the accurate depiction of the new and exotic. People and goods from distant lands were brought to Europe where they fascinated and inspired artists such as Dürer and Rembrandt. For instance, in the seventeenth century Rembrandt drew portraits of African musicians whom he may have seen taking part in a celebratory pageant held in The Hague (fig. 30).

28 Figure of a woman in European dress with a man attached
Haida, Northwest Coast of America, mid-nineteenth century
Argillite, 24 cm
Haida artists excelled in the creation of carved caricatures of Europeans and Americans, particularly sailors. Here the artist is possibly commenting visually on the relationship between a couple known to him, or representing an image from a publication in which the man is standing some distance behind the woman. It may also be that the woman is not of European descent, but instead the Native consort of a Canadian. In this case the carving may indicate the importance of the female line in matrilineal Haida society.

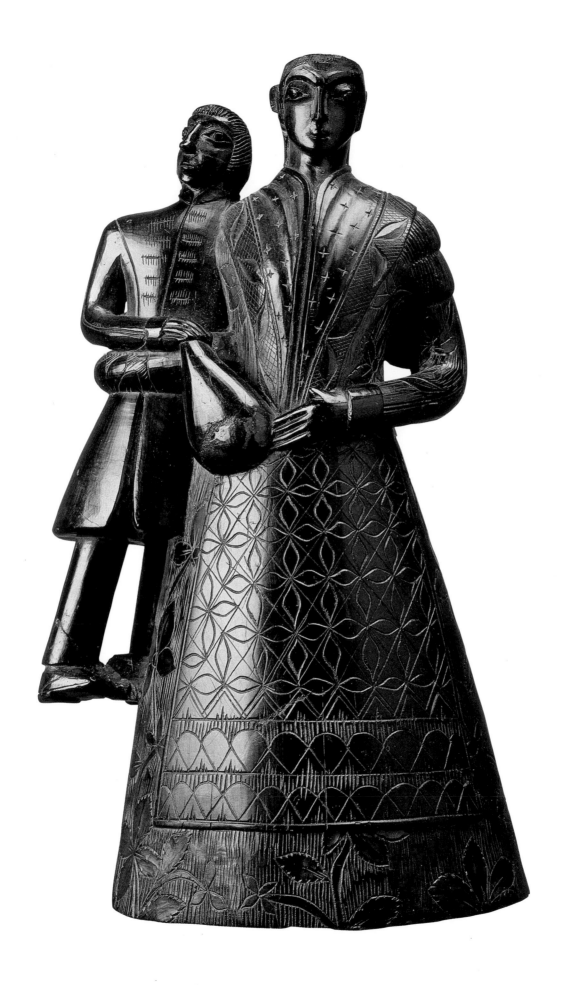

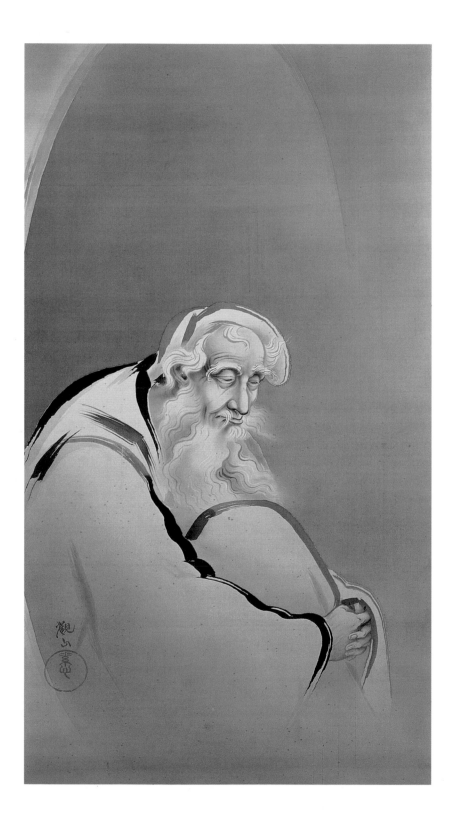

◁ 29 *Diogenes* **by Shimomura Kanzan (1873–1930)**
Japan, 1903–5
Hanging scroll, 131.3 x 72 cm
The eccentric Greek philosopher Diogenes sits at the rim of the barrel in which he lived, clasping his knees, lost in thought.
The ink technique and hanging-scroll format are traditionally Japanese, but the subject chosen is quintessentially European and there is a self-consciously Western sense of modelling given to the facial features, reminiscent of Leonardo da Vinci's *Self-Portrait*.

30 *A black drummer and commander mounted on mules* **by Rembrandt (1606–69)**
Holland, c. 1638
Drawing in pen, ink and wash over red chalk, 22.9 x 17 cm
Rembrandt's work is full of evidence of his fascination with the people and goods that came from distant lands to the great trading nation of Holland. It is possible that this drawing represents two of the black musicians who took part in a pageant held in The Hague in 1638 to celebrate the marriage of the sister of the Princess of Orange.

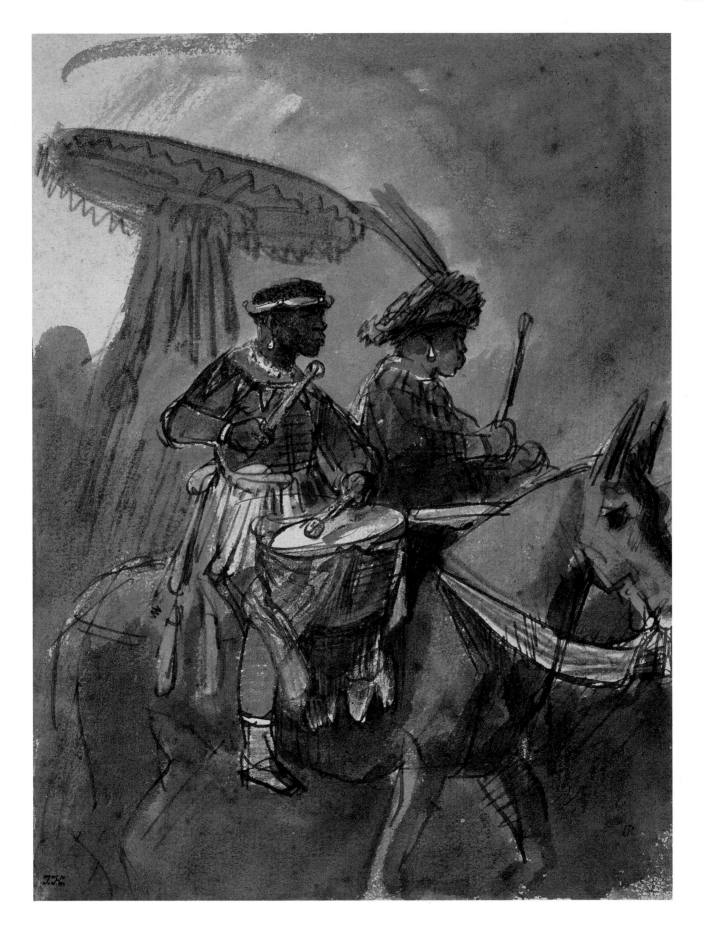

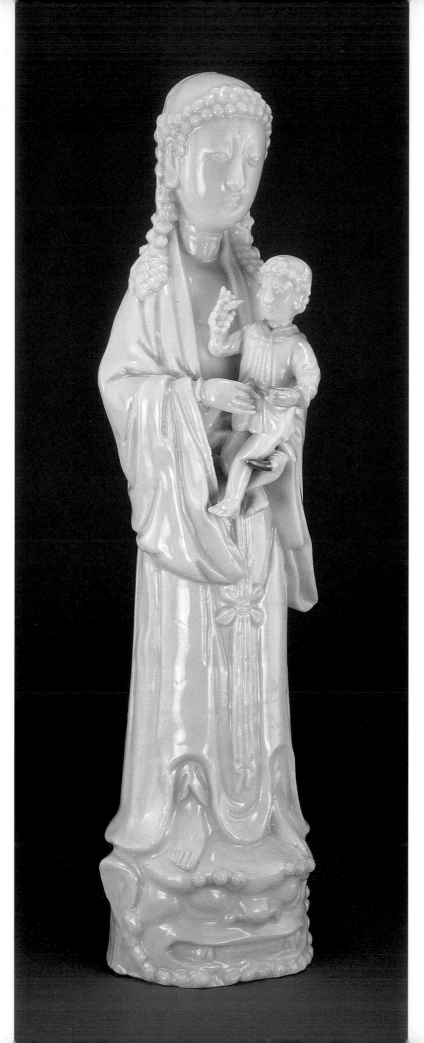

31 Madonna and Child
Dehua, Fujian province,
China, late seventeenth to
early eighteenth century
Porcelain, 25 cm
This Chinese *Blanc de Chine*
figure of a woman holding an
infant was influenced by the
Virgin and Child figures made
by Chinese craftsmen for the
Spanish, who established a
trading centre in the
Philippines in the second half
of the sixteenth century.
Images of Guanyin (the
bodhisattva Avalokiteshvara)
holding a child are similar but
lack the European features
and curly hair. Guanyin images
were not only produced in
moulded white porcelain but
also in carved ivory.

**32 Salt cellar
surmounted with the
figure of the Virgin and
Child**
Sherbro, Sierra Leone,
sixteenth century
Ivory, 28 cm
Salt cellars were among the
very first objects
commissioned by Europeans
from African artists to be
taken home as souvenirs.
They thus show the
interaction of two different
artistic traditions within a
single object. It seems from
contemporary accounts that
Africans reinterpreted newly
available images from
European engravings and
book illustrations.

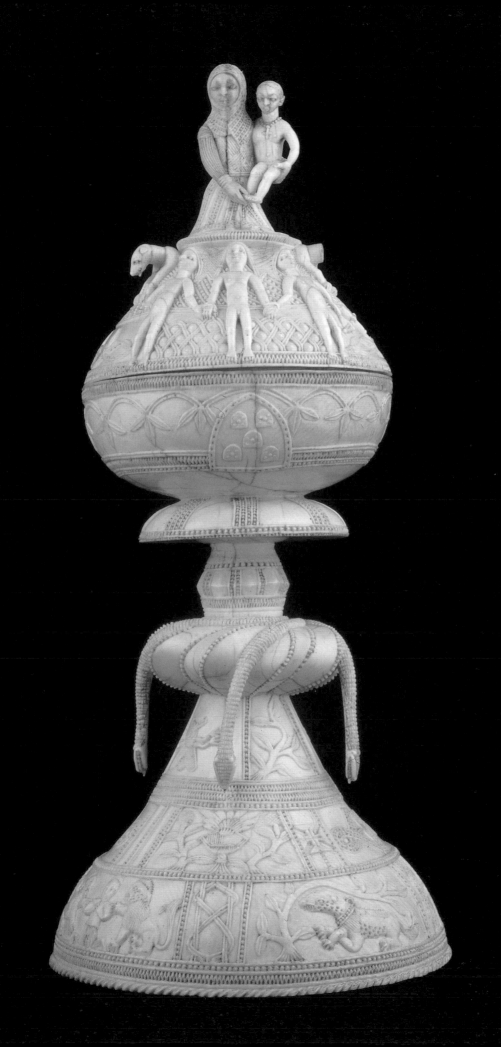

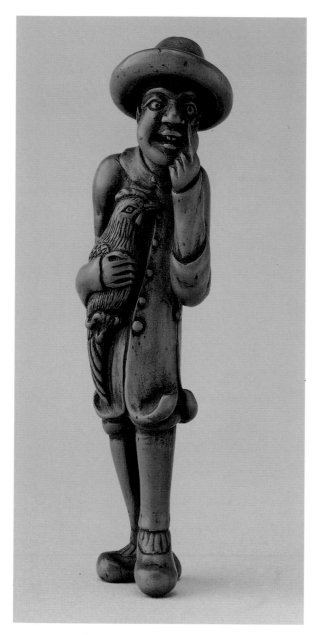

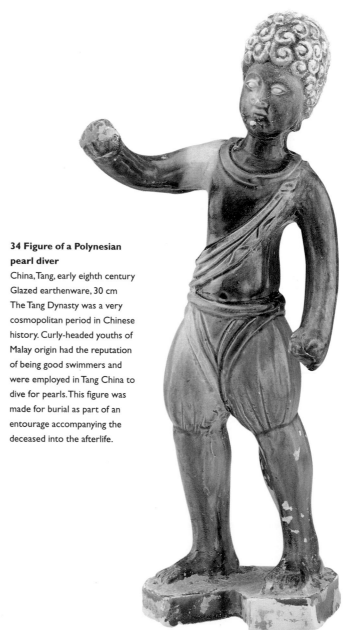

◁ **33 Netsuke of Dutchman with cockerel**
Japan, eighteenth century
Boxwood, 13.5 cm
The Dutch were the only Europeans permitted residence in Japan during much of the Edo period. This humorous example of a Dutchman carrying a cockerel is possibly a comment on their diet. He is making a Japanese derisory gesture by pulling down one eyelid.

34 Figure of a Polynesian pearl diver
China, Tang, early eighth century
Glazed earthenware, 30 cm
The Tang Dynasty was a very cosmopolitan period in Chinese history. Curly-headed youths of Malay origin had the reputation of being good swimmers and were employed in Tang China to dive for pearls. This figure was made for burial as part of an entourage accompanying the deceased into the afterlife.

35 (facing page) Portrait of three Micronesians – Kokiuaki and his sisters, executed in the style of New England portraiture by the Chinese artist known in the West as Spoilum (fl. 1770–1810)
China, 1791
Oil on canvas, 100 x 65 cm
Captain John McLuer, of the *Panther*, took three Palauans to China in early 1791, where several portraits of them were made for his officers. One portrait was sent to Johann Friedrich Blumenbach, professor of anatomy at Göttingen, and the founder of anthropology. Blumenbach maintained that there was one human race, and assembled a collection of images of exotic peoples, with the help of Sir Joseph Banks, scientist and British Museum trustee.

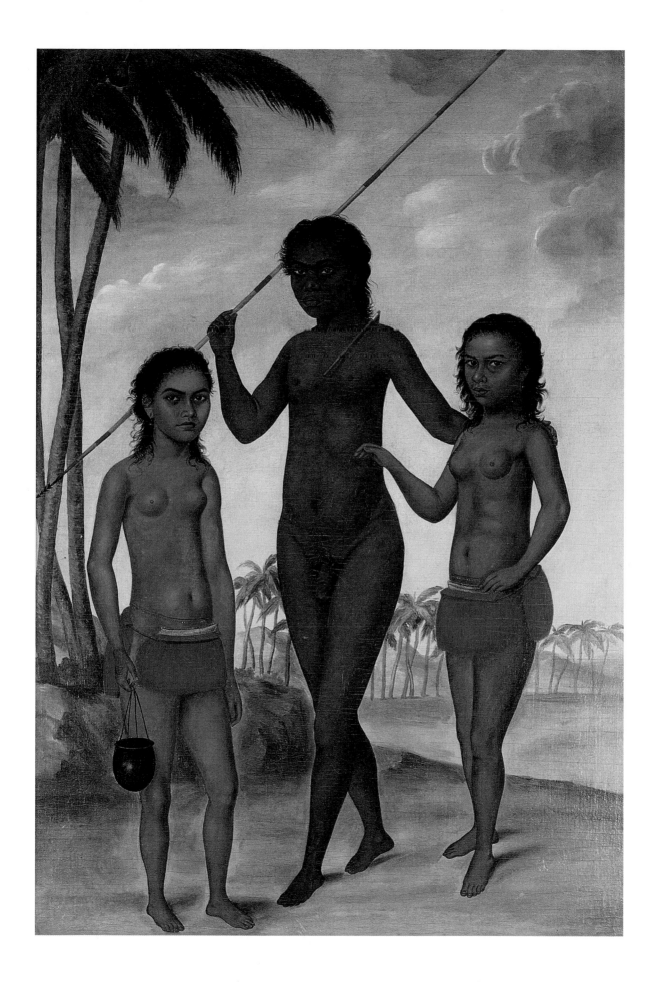

'At that time I fashioned a heroic image of my royal self, my power and my glory I inscribed thereon, in the midst of his palace I set it up. I fashioned memorial steles and inscribed thereon my glory and my prowess, and I set them up by his city gate.'

Ashurnasirpal II, King of Assyria, 883–859 BC

power

Power is an essential feature of relationships between people. Images of temporal and spiritual rulers help to sustain their authority and justify the distribution and application of power. Such images may feature both realistic and symbolic features. The Assyrian king Ashurnasirpal II (fig. 37), from ninth-century BC Nimrud, is shown as an emphatic, unassailable authority through both his stance and the symbols of office that he carries. In intent this is not dissimilar to the Kuba king figure from Central Africa (fig. 41), with the drum which symbolizes his reign. Queen Elizabeth I's authority is similarly expressed in a portrait medal by Nicholas Hilliard (fig. 39), where she is shown in full regal splendour. It was perhaps for presentation to a favourite courtier who, by wearing it, would then transmit this commanding image of his queen to anyone he encountered. Temporal and religious authority may be invested in the same person or office, as in the eighth-century Maya lintel (fig. 38) which depicts Bird Jaguar standing over a noble captive, letting blood.

Dynastic prerogatives may be defined and validated by the use and reinterpretation of ancient and ancestral images; these are often idealized since reliable portraits may not be available. The representations of chiefs and monarchs, ancestors and deities are adapted from such images to project ideal authority extending beyond the physical. In the Yoruba veranda post (fig. 36) a woman with child upholds the position of an African chief, expressing both respect and fecundity. Naturalistic copper alloy heads, symbols of inherited power and tradition, were cast after the death of kings in Benin and placed on altars (fig. 40). The Japanese wood and lacquer ancestral figure of a retired merchant-turned-priest, from about 1700, would have been revered on a domestic altar (fig. 42).

36 Yoruba house post carved with woman and child

Nigeria, twentieth century
Wood, 180 cm
Yoruba houses belonging to notables are distinguished by the use of elaborate posts that support the roof. These may be carved with figurative or geometric designs. A favoured image is that of a kneeling female in a posture of respect. This figure bears a baby on her back, implying that the household is ultimately supported by women and their child-bearing powers.

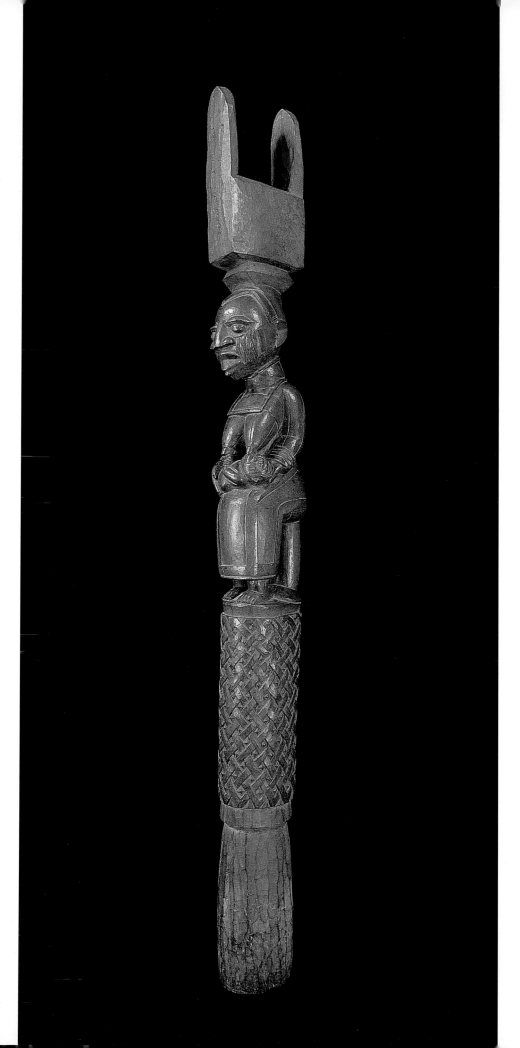

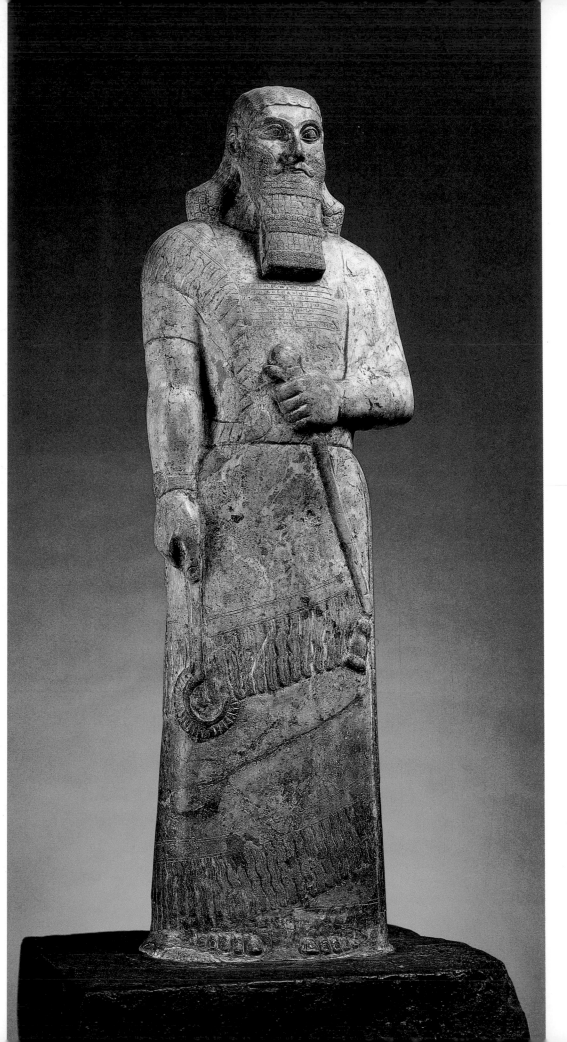

◁ **37 Ashurnasirpal II,
King of Assyria**
Nimrud, Iraq, c. 865 BC
Magnesite, 106 cm
The King of Assyria was
High Priest of the god Ashur,
divinely appointed to govern
the land on behalf of the
gods. This statue shows
Ashurnasirpal wearing the
fringed robe of the High
Priest, and holding in his left
hand the mace which
symbolized authority.
The sickle-sword in his right
hand was a weapon also
used by gods. The unusual
stone, magnesite, was
probably acquired during
one of his campaigns, and
the inscription on his chest
mentions his expedition to
the Mediterranean Sea
in the far west.

38 Temple lintel (16)
Maya, Yaxchilan, Mexico,
Classic period (AD 250–900)
Limestone, 76.2 cm
Lintel 16 is one of a series of
three panels set above a
central doorway in Structure
21 at Yaxchilan. The scene is
dominated by Bird Jaguar IV,
the king of Yaxchilan, attired
in a warrior costume and
with a spear in his right hand.
A captive sits at his feet
carrying a broken parasol,
an attribute of defeated
warriors. Bird Jaguar,
Yaxchilan's most prolific
builder, commissioned a
series of lintels
commemorating his battles
and other events to
consolidate his power.

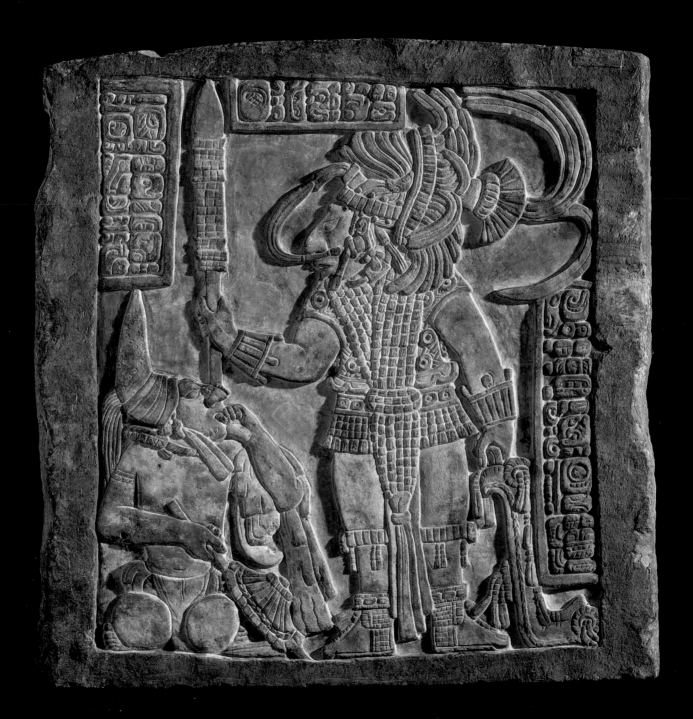

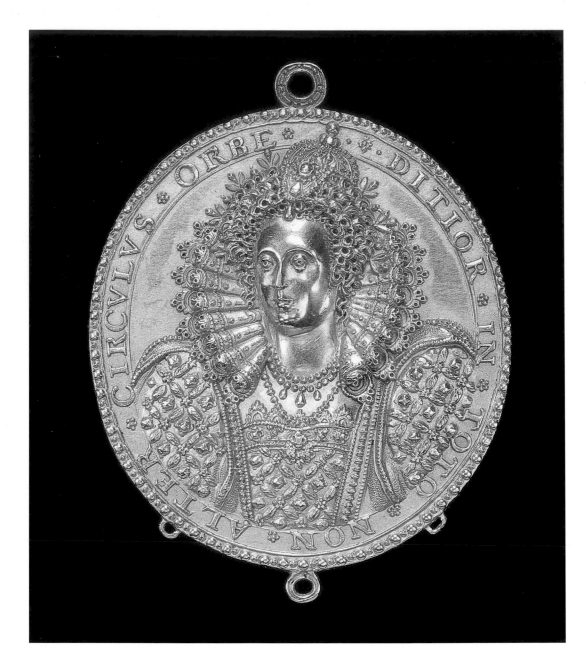

**39 Medal of Elizabeth I,
Queen of England and
Ireland (1533–1603)
by Nicholas Hilliard
(c.1537–1619)**
England, c. 1580–90
Cast and chased gold,
5.6 x 4.4 cm
It is probable that this
piece was originally a costly
gift from Queen Elizabeth
herself to a favoured
courtier or a political ally.

40 Cast head
Benin, Nigeria,
fifteenth century?
Brass, 23 cm
Copper and its alloys were
considered a royal material in
Benin and heads such as this
were cast after the deaths of
kings (Obas) exclusively for
the altars of Benin City, being
commissioned by the heir to
the throne.

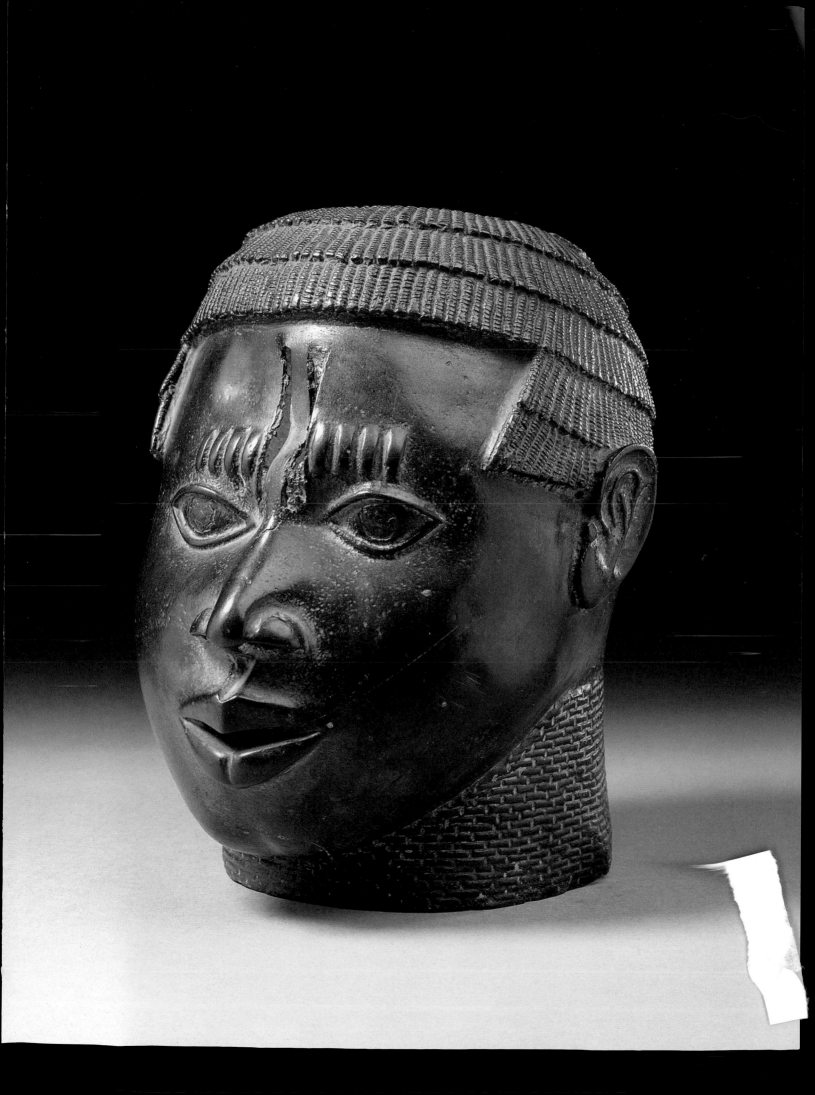

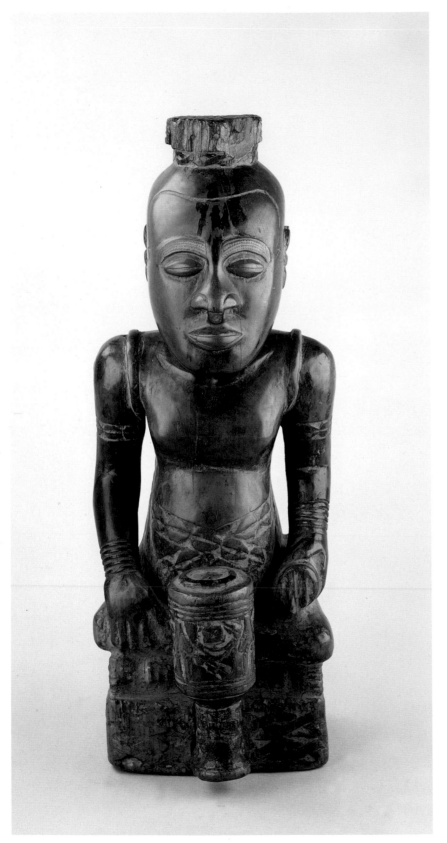

◁ **41 Kuba-Bushoong figure commemorating King MishaaPelyeeng aNce**
Democratic Republic of Congo,
probably late eighteenth century
Wood, 54 cm
The Kuba people carved figures, *ndop*, of past rulers, each being identified by an object associated with the reign of that particular king – in this case a drum. These figures were kept in the royal shrine at Nsheng, the capital of the Kuba kingdom. They were not portraits as such, but rather represented a distillation both of the spirit of a particular ruler and of the principles of kingship.

42 A Retired Townsman
Japan, Edo period, seventeenth to eighteenth century
Wood and painted crystal, 42.5 cm
Secular portraits such as this became popular with the increasing prosperity of the merchant and artisan classes in the growing cities of seventeenth-century Japan, when they were made for ancestral veneration. The shaven head of this figure may indicate that he has undergone a change in life after the age of sixty, a complete zodiacal cycle, possibly becoming a lay Buddhist monk.

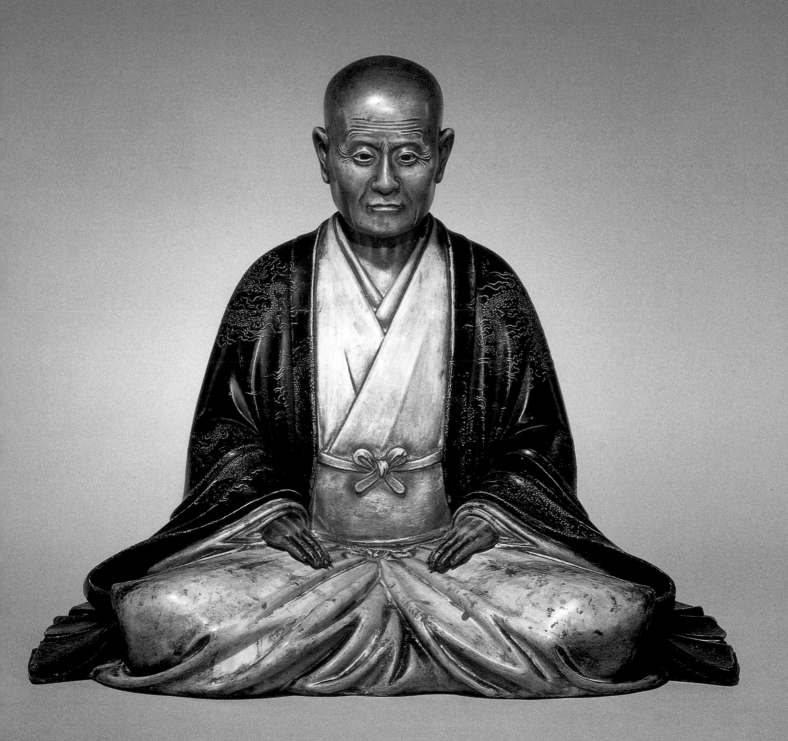

drapery

The addition of drapery to the human form may enhance the body's appearance and explain the status of the wearer. Flowing clothing may create an illusion of softness and movement, shadow and light. Greek sculptors of the classical period excelled in the realistic depiction of drapery, as in the fourth-century BC marble of a Nereid, or sea nymph (fig. 47). In this tomb sculpture the Nereid's clothing is wet and clings to her body as she accompanies the deceased across the waves to paradise. Ancient Greek conventions for depicting drapery were taken up by the artists of Afghanistan and north-west Pakistan, and redefined in the Buddhist world of East Asia. The Buddha here (fig. 46), of the first century AD, wears clothing local in flavour and inspiration, but suggesting stillness, dignity and order.

Drapery has often been used as an expression of artistic virtuosity. During the Renaissance artists such as Fra Bartolommeo, in his drawing for a figure of Christ in the *Last Judgement* (fig. 43), studied the folds of cloth which had been dipped in liquid clay. Billowing silk clothing is masterfully depicted in the eighteenth-century Japanese print of a courtesan (fig. 44). Matisse, working in Nice in the late 1930s, adopted an almost sculptural approach to drapery in this drawing (fig. 45) related to a series of paintings of models dressed in elaborate costumes.

A far more abstract approach is apparent in the idealized depiction of clothing in ancient Egypt or Native North America. Kilts and bark skirts may be shown without creases or folds, protecting the body by projecting an image of invulnerability. This can be seen in the stiff and formal figure of the Egyptian King Nectanebo I (fig. 49; of the same period as the Nereid) and in a nineteenth-century entombed Haida figure, from the Northwest Coast of America (fig. 48).

43 *Study of drapery for the figure of Christ* by Fra Bartolommeo (1472–1517)
Italy, 1499
Brush drawing on linen, 30.5 x 21.2 cm
It was standard practice in Florentine artists' studios of the late fifteenth century to drape cloth dipped in liquid clay over models which would then remain in place to be used as the basis for studies of drapery. This is one of the latest such studies to survive.

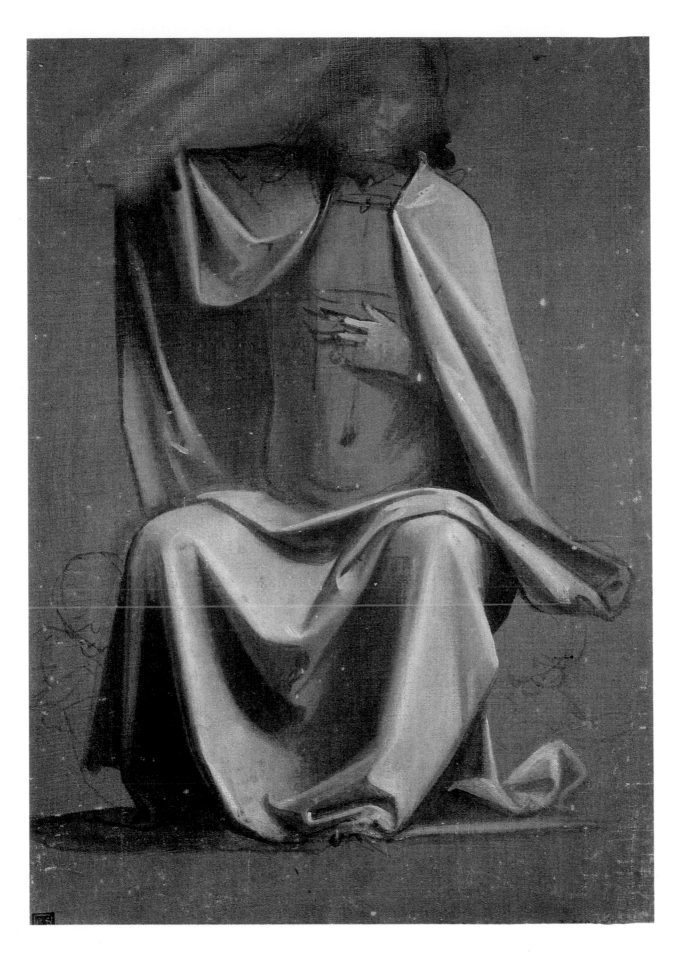

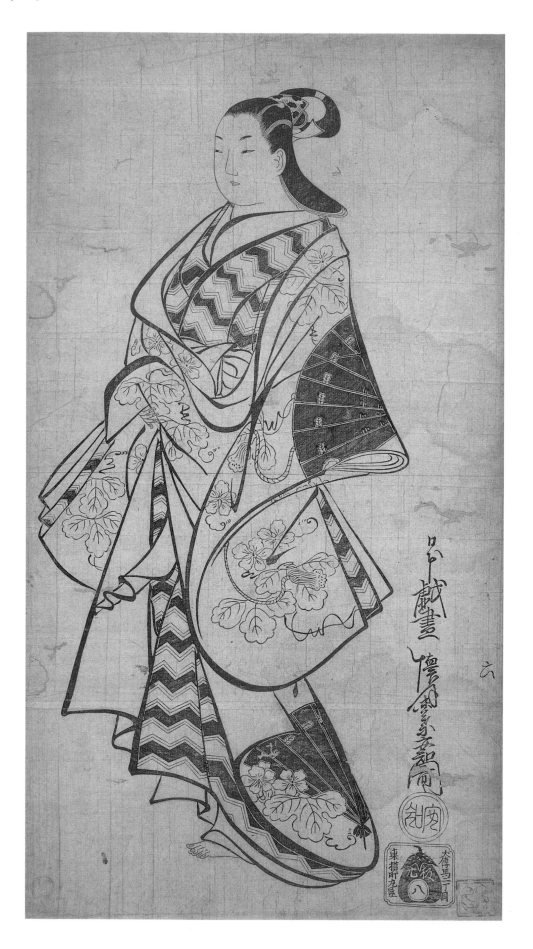

◁ **44** *Courtesan* **by Kaigetsudō Anchi**
Japan, *c.* 1710–20
Woodblock print, 59 x 32 cm
A high-ranked courtesan of the Yoshiwara pleasure quarter in Edo (modern Tokyo) wears a surcoat (*uchikake*) with a bold overall design of scattered court fans and flowering 'evening face' vine (*yūgao*), over a kimono with eye-catching zigzag stripes. The 'evening face' design alludes to a chapter from the classical novel *Tale of Genji*.

45 *Seated woman in a taffeta dress* **by Henri Matisse (1869–1954)**
France, 1938
Charcoal drawing, 65.8 x 50.3 cm
The drawing belongs to a group of charcoal studies in which the artist describes the volume and planes of the figure in an almost sculptural manner. *Seated woman in a taffeta dress* also relates to the paintings Matisse produced in Nice in the late 1930s of female models dressed in elaborate costume. The most famous of these works is the painting *The large blue robe and mimosas* of 1937 (Philadelphia Museum of Art).

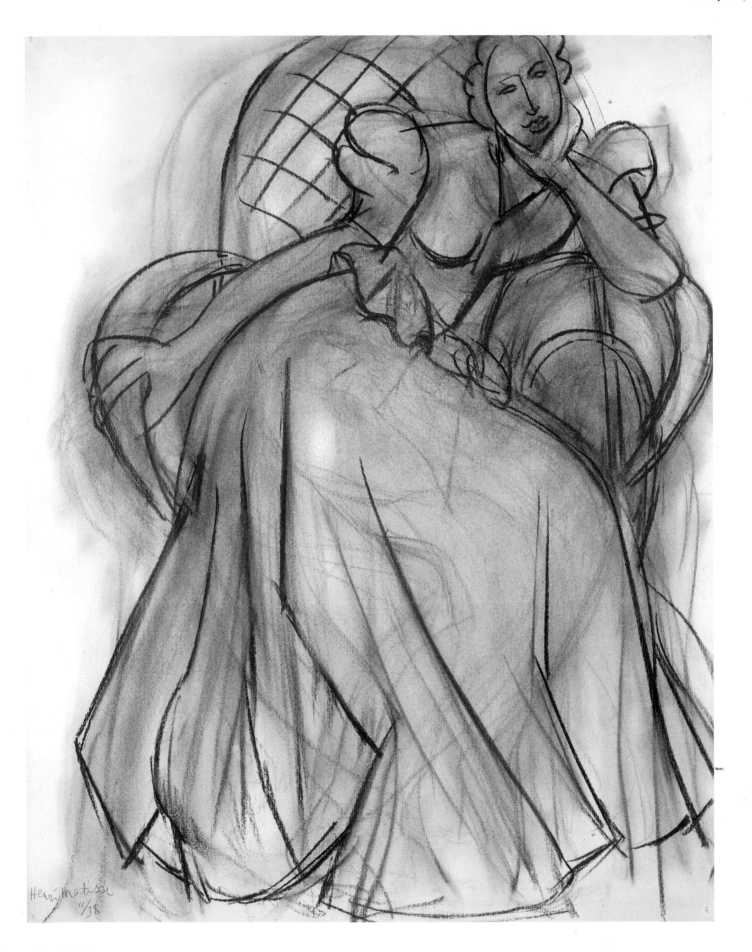

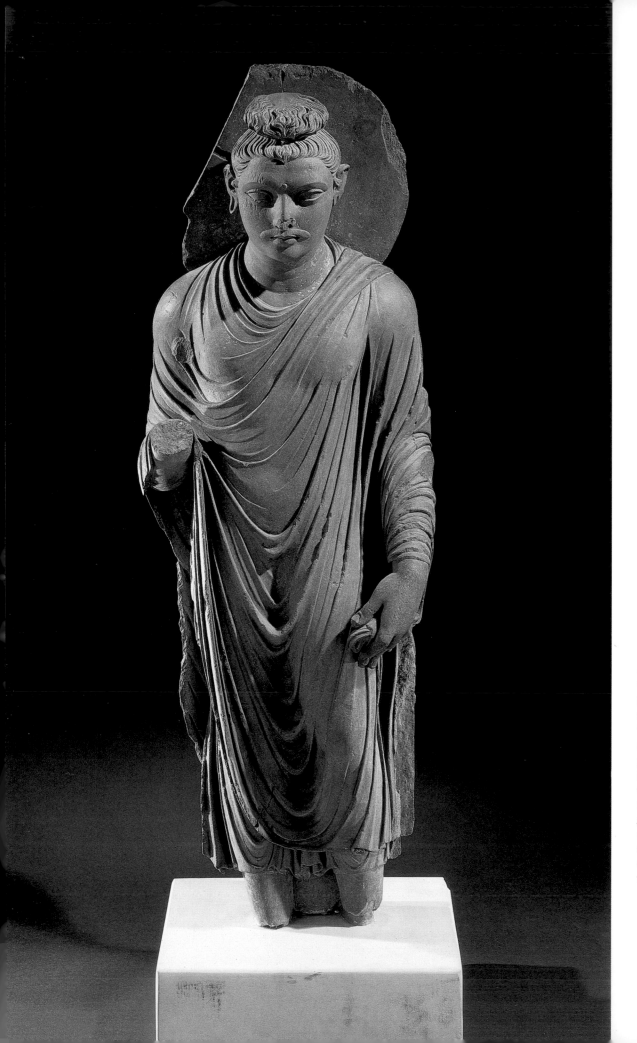

46 Standing Buddha
Takht-i Bahi, north-west
Pakistan, first century AD
Schist, 100 x 30.2 cm
The sculptural traditions
of Gandhara, though
predominantly Indian and
Buddhist in subject-matter,
were clearly influenced by
Greco-Roman models. The
garment on this figure
suggests devout simplicity
and calmness – a stark
contrast to the garment
worn by the Nereid figure.

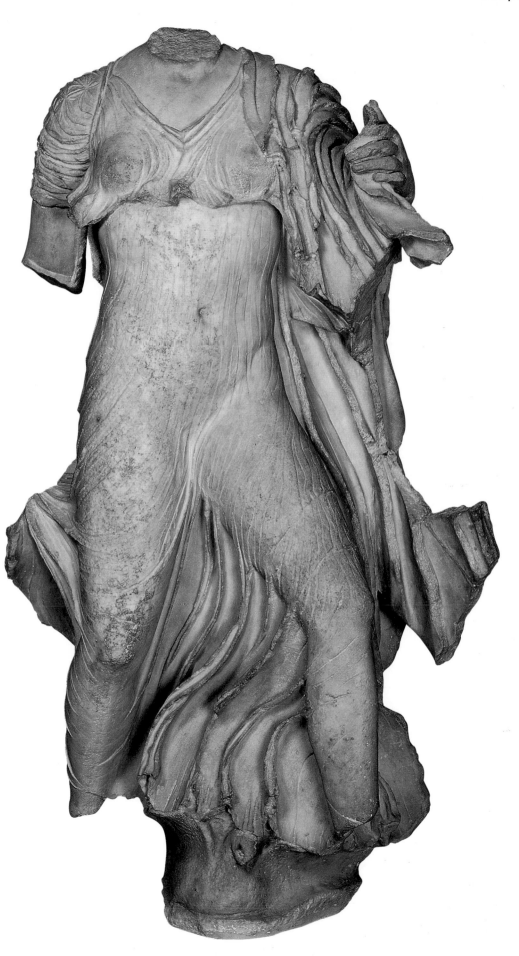

47 Sea nymph, 'Nereid'
From a monumental tomb erected at
Xanthos in Lycia, now south-west Turkey,
c. 400 BC
Marble, 140 cm
Greek sculptors of the classical period
excelled in realistic and expressive
representation of drapery. The anonymous
carver of this daughter of the sea god
Nereus has rendered her clothing damp
with sea spray. It is pressed flat against her
body by the force of the wind or flies
billowing freely around her.

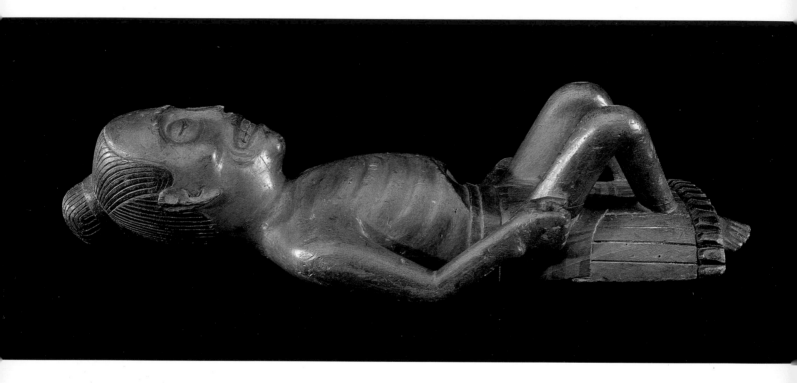

**48 Figure of dead shaman prepared for burial
by Simeon Stilthda (c. 1800–89)**
Haida, Northwest Coast of America, nineteenth
century
Painted wood, 60 cm
Stilthda was a skilled and productive carver, a Raven
Chief, who created a number of similar figures for
sale. Originally the dead were placed in a chest,
decorated with animal crests, on top of two posts.
The man is shown wearing what is probably an
unwoven kilt or skirt of shredded cedar bark, in which
the flexibility of the material has been eliminated.

49 Statue of King Nectanebo I
Saft el-Hinna, Egypt, c. 370 BC
Black granodiorite, 155 cm
Fragment of a statue of King Nectanebo I (380–362 BC)
discovered at Saft el-Hinna, and probably dedicated in the
temple of the god Sopdu there. Wearing the short pleated kilt
of royalty, the king stands in the traditional pose of Egyptian
statues with his left leg forward.

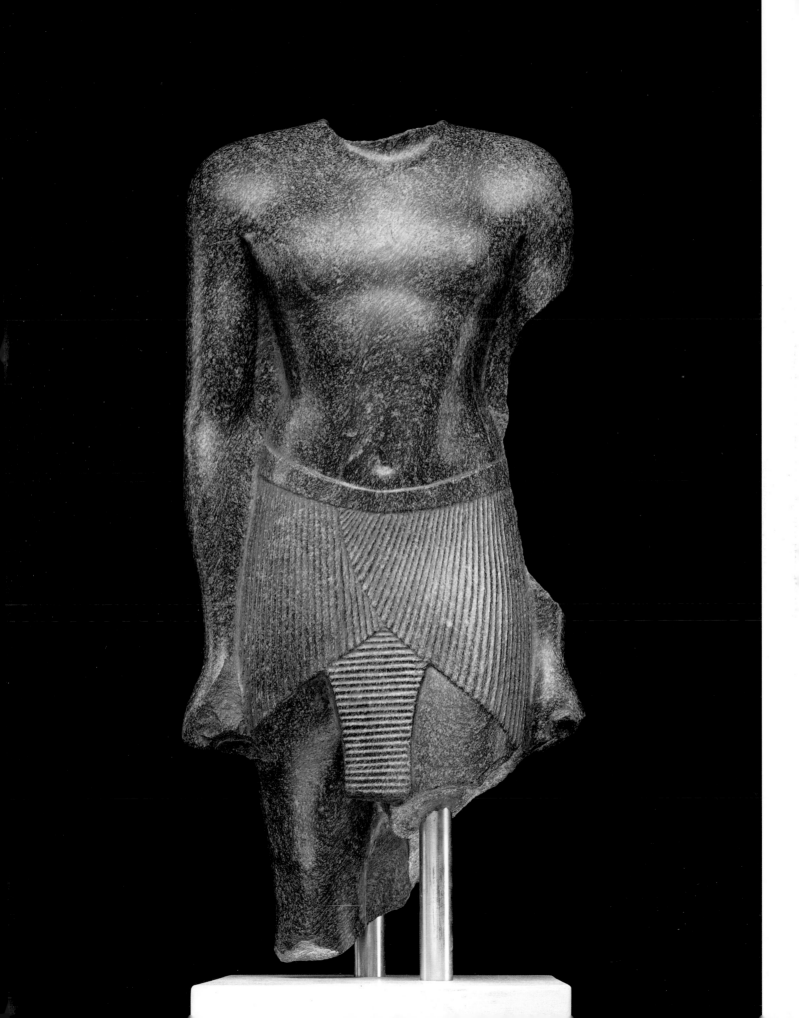

'More people are ruined by victory, I imagine, than by defeat.'

Eleanor Roosevelt, 1938

guardians

Figures of protection may be recognized by their physical and spiritual attributes. The large and intimidating temple figure of the war god Ku-ka'ili-moku (fig. 50) was erected by King Kamehameha I, unifier of the Hawaiian Islands, at the end of the eighteenth century. Its hair is composed of pig heads, perhaps indicating wealth. Protective figures often incorporate animal features, common ones being birds of prey, such as Isis' vulture wings, and large felines, including the lion on the Leonardo da Vinci breastplate (fig. 57); thus the primeval forces of nature are invoked.

Protection may be provided for individuals by charms and animal spirits, or the guardianship of gods, goddesses and saints. Isis, one of the central goddesses of ancient Egypt, is shown in this sixth-century sculpture (fig. 51) enveloping her husband Osiris, whom she has revived from the dead. At Nineveh in ancient Assyria, palaces were built with the elaborate depiction, in low relief wall sculpture, of warriors, like the two illustrated here (fig. 55).

The exaggeration of weapons and armour is designed to overawe and deter. For example, Leonardo's bust depicts a man wearing a magnificent Renaissance Italian helmet. The armour of the Japanese warrior in the Yoshitoshi print (fig. 56) consists of imposing overlapping plates. The two shields shown here would not have been used in battle. The medieval example (fig. 53), depicting a knight and lady with the figure of death in the background, may have been a prize for a tournament. The nineteenth-century shield from the Solomon Islands (fig. 54), depicting a man and trophy heads, seems to have been carried as an item of prestige.

50 Temple figure
Hawai'i, 1790–1810
Wood, 272 cm
In the 1790s and 1800s
King Kamehameha I built
a number of temples to his
god, Ku-ka'ili-moku
(Ku, the island snatcher),
in Kona, Hawai'i, seeking
the god's support in his
further military ambitions.
This figure is likely to have
been a subsidiary image in
the most sacred part of
one of these temples:
not so much a representation
of the god as a vehicle for
the god to enter.

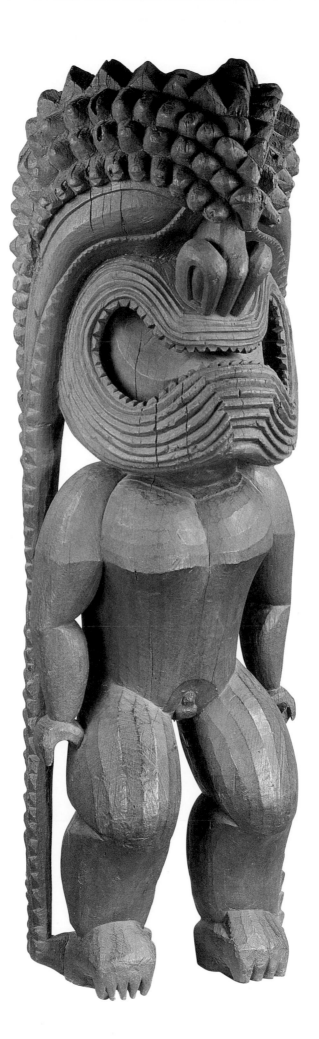

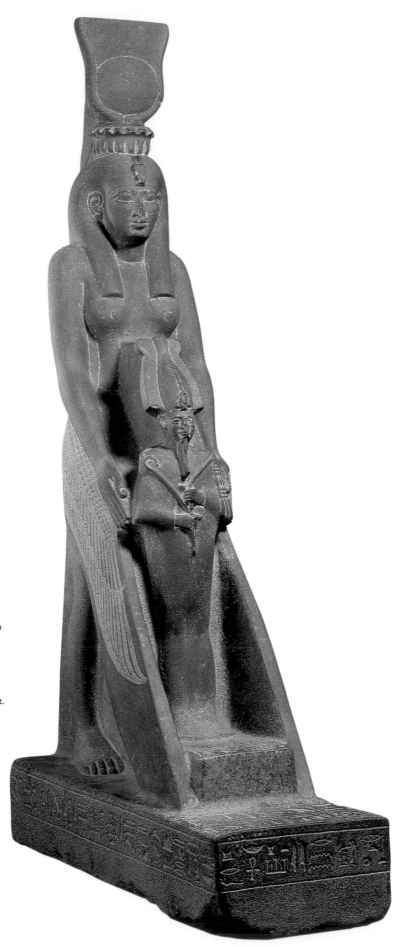

**51 Statue of Isis
protecting Osiris**
Thebes, Egypt, c. 580 BC
Grey siltstone, 81.3 cm
The goddess Isis is shown with
wings stretched out to protect an
image of her mummified husband
Osiris-Wennefer, whom she
resurrected after his murder.
Egyptian deities often have wings
to indicate their protective aspect.
The hieroglyphs on and around
the base include a prayer that Isis
should give him a long life.

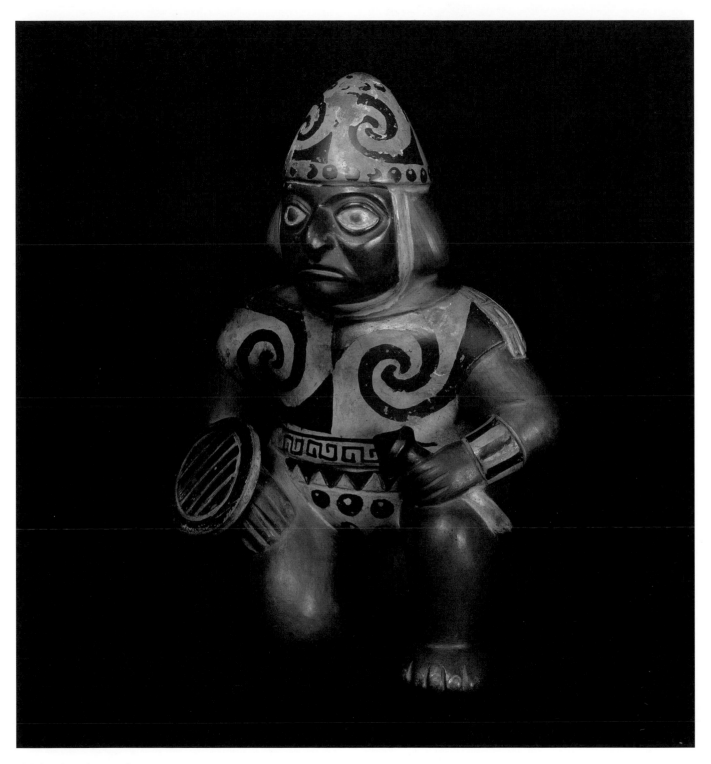

52 Painted warrior vessel
Moche, Peru, AD 250–550
Pottery, 22.5 cm
Warriors constituted a high-ranking class in Moche society. They bear clubs, shields
and helmets and are sometimes depicted with animal attributes such as owls, jaguars,
humming birds or foxes. The characteristic traits and qualities of these creatures were
evidently emulated by successful warriors. The main objective of Moche warfare seems
to have been the capture of prisoners for later sacrifice at ceremonial events.

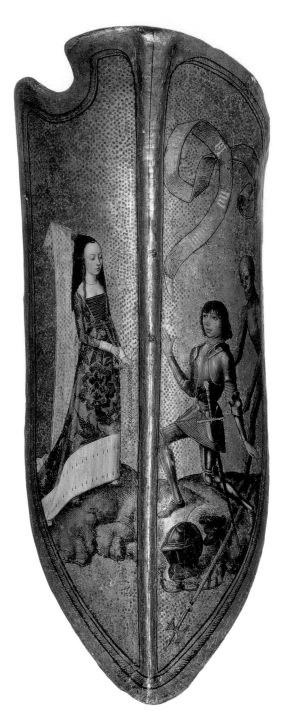

55 Low relief wall-panel depicting royal bodyguards
Nineveh, Iraq, *c.* 700 BC
Alabaster, 160 cm
These two bodyguards, one an archer and one a spearman, are carved on a wall-panel from the palace of Sennacherib, king of Assyria. They were part of a long row of panels showing a procession in which the king, accompanied by senior officials and priests, progressed from his palace to a nearby temple.

▷ **54 Shield depicting human figure**
Central Solomon Islands, early nineteenth century
Plaited cane, shell, and vegetable putty, 87 cm
Inlaid shields such as this have not been made in the Solomon Islands since about 1850 and little is known about their use. They seem to have been carried as a mark of prestige, and to have been treated as valuables. The human figure is probably the image of a warrior; the small heads towards the bottom are likely to refer to head-hunting.

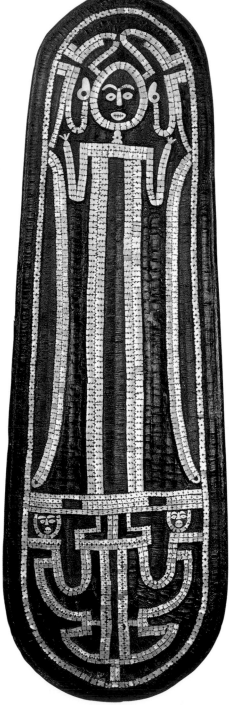

53 Flemish shield
Flanders or Burgundy, late fifteenth century
Wood, 83 cm
An armed knight kneels before his richly dressed lady, possibly prior to tournament or battle. The motto 'You or Death' floats above, and a skeletal figure of Death reaches out to seize the knight.

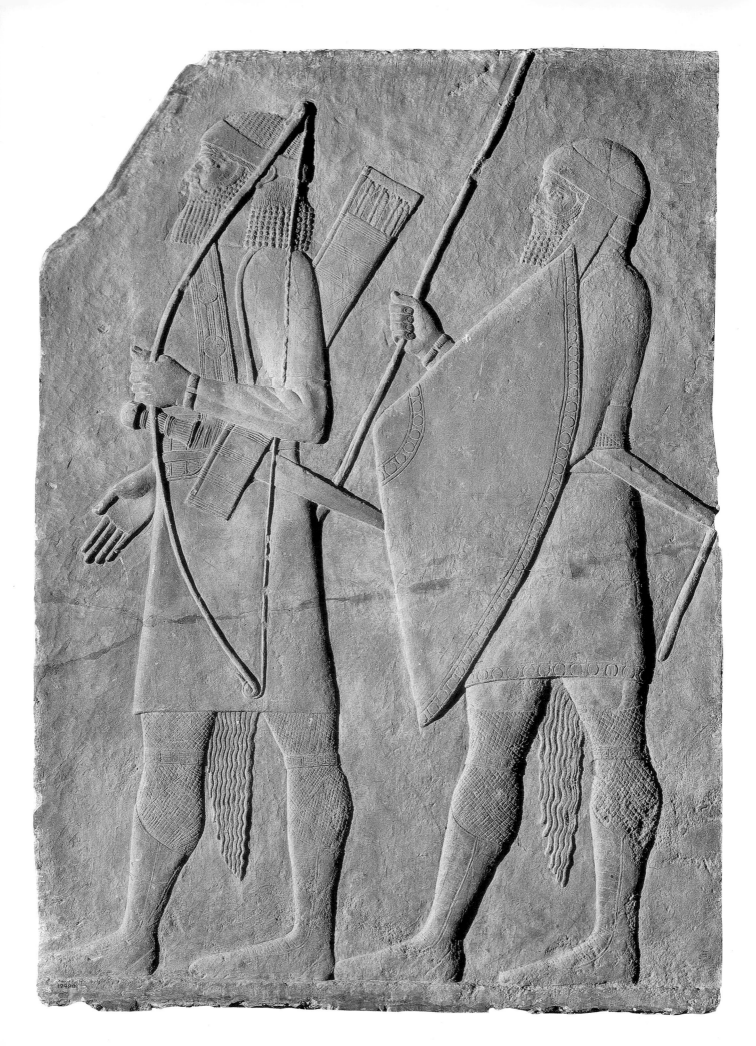

今川治部少輔源義元

伊藤日向守首

◁ **56** *Imagawa Yoshimoto* **by Tsukioka Yoshitoshi (1839–92)**
Japan, *c.* 1870s–80s
Brush drawing, 55.9 x 40.6 cm
Imagawa Yoshimoto (1519–60) was a powerful provincial warrior during Japan's interminable civil wars of the sixteenth century. Here he inspects the severed head of an enemy, Lord Itō of Hyūga, presented on a ceremonial stand.

57 *Warrior in a winged helmet* **by Leonardo da Vinci (1452–1519)**
Italy, *c.* 1475–80
Drawing in metalpoint on prepared paper, 28.7 x 21.1 cm
This drawing is thought to have been inspired by a bronze relief of the great Persian Emperor Darius, now lost, by Leonardo's master, Andrea del Verrocchio. It would have been drawn at an early stage in Leonardo's career when his personal style was beginning to develop.

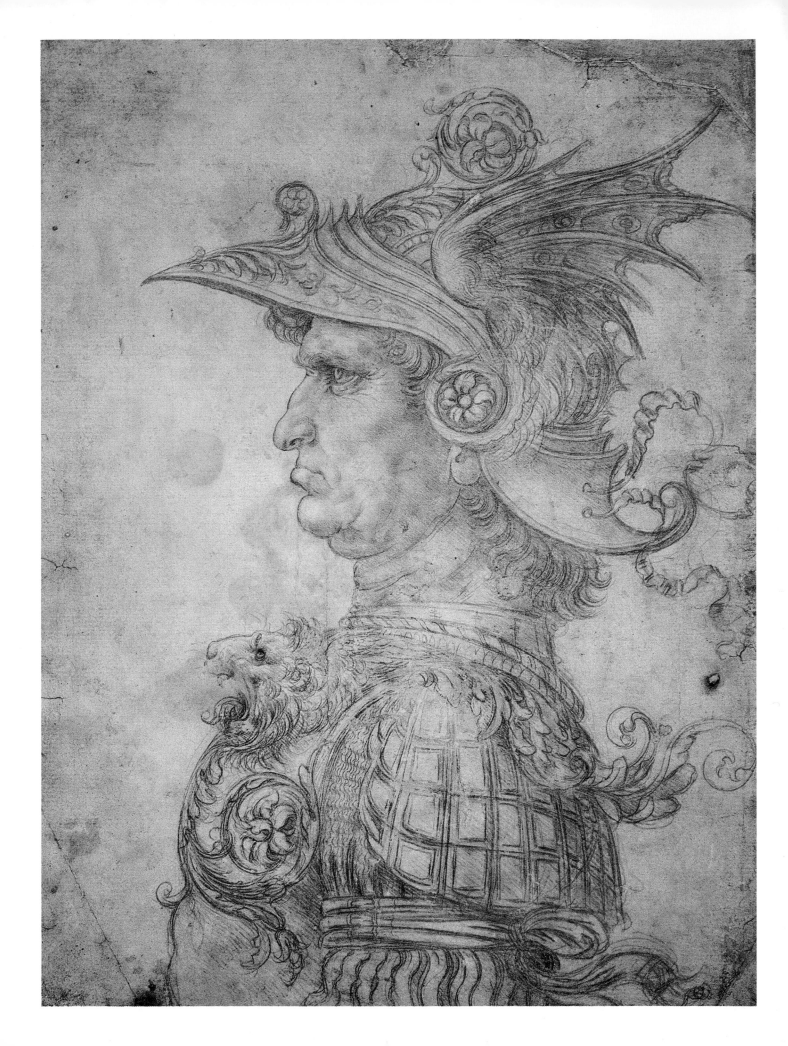

'I still recall, with something of a shock, the moment, at the
end of the first sitting, when I looked at what had been a
lump of clay, and found that a third person was in the room.'

Sir John Pope-Hennessy (1913–1994), on seeing his portrait

portraits

Portraits can be created either for private use or public display. The two
funerary portraits here both illustrate a personal approach and a desire to pre-
serve the individuality of the deceased. The Fayyum portrait from a Greco-
Roman mummy (fig. 58) appears to be a naturalistic rendition of the subject, thus
perpetuating the memory of her physical appearance. In the memorial bust of
Tamma from Palmyra (fig. 62) the sitter is surrounded by the splendour of her
worldly possessions, a testament to her success in life. The fifteenth-century
drawing of a woman by Rogier van der Weyden (fig. 59) also suggests something
of the sitter's character.

In the Renaissance, portrait medals were produced by members of promi-
nent families, promoting themselves as inspiring moral examples. This was a much-
favoured form of portraiture as medals were easily portable, and could bear a
further emblem, motto or allegory on the other side. The medal of Giulia Astallia
(fig. 60) depicts her as a model of beauty, believed to be the outward expression of
modesty.

Official representations of leaders are often bolder and more stylized in
order to legitimize power and authority, as in the figure of Gudea, an early
Mesopotamian ruler (fig. 61). The Chinese image of Chairman Mao (fig. 64), from
the 1990s, would be placed in the home, having acquired almost a talismanic quality.

The self-portrait by the Creek prophet Chief Francis, from Alabama
(fig. 63), was, it is said, created the first time he was given a pen. This seemingly
naïve portrait in fact depicts the details, such as his pipe, with great accuracy.

**58 Mummy portrait
of a woman**
Hawara, Fayyum, Egypt,
AD 100–120
Encaustic on limewood, 38.2 cm
Mummy portrait excavated by
Flinders Petrie in 1888. Such
portraits were attached to
Egyptian-style mummies.
Realistic likenesses recording
the personal features of the
deceased were the result of
Greco-Roman influence.

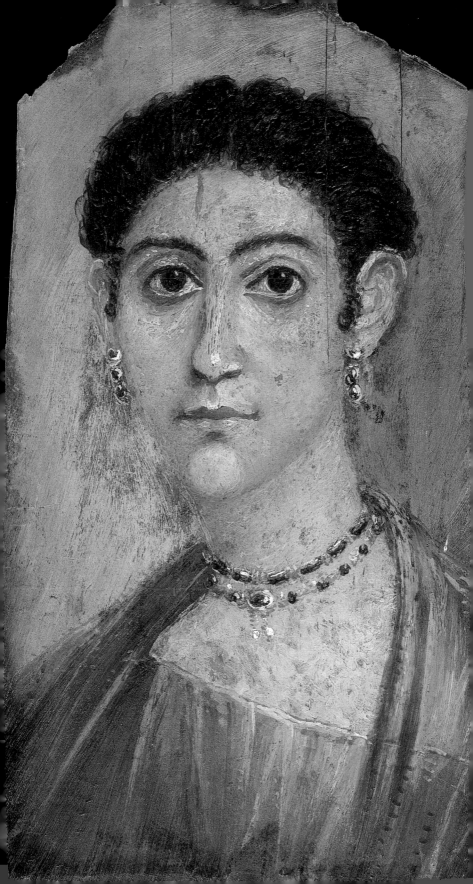

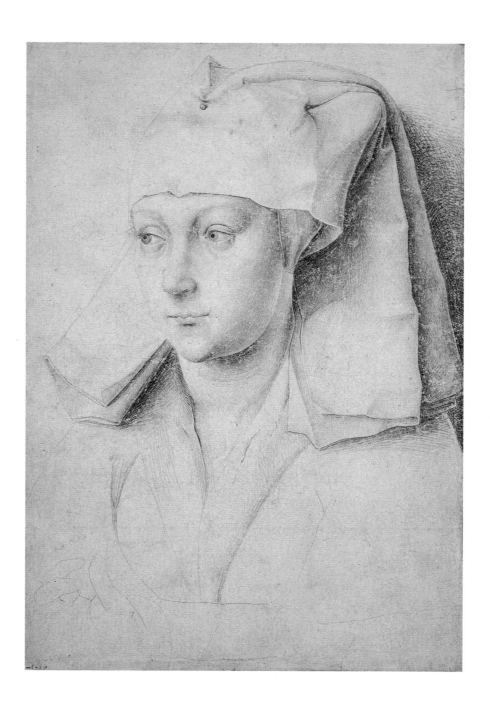

◁ **59 *Portrait of an unknown woman* by Rogier van der Weyden (c. 1400–64)**
Flanders, *c.* 1430–40
Drawing in metalpoint on prepared paper, 16.6 x 11.6 cm
Rogier van der Weyden was the major Flemish artist of his time. His sensitive depiction of human emotion made his portraits convincing records of his sitters' characters as well as their appearance. This drawing cannot be connected with any known painting but the sitter bears a resemblance to Jeanne de Presles, the mistress of Rogier's patron, Philip the Good, Duke of Burgundy.

60 Portrait medal of Giulia Astallia
Mantua, *c.* 1480–90
Cast bronze, diam. 6.4 cm
This medal promotes Giulia Astallia as a model of beauty, believed to be the outward expression of modesty, particularly desirable for Renaissance women. She casts her eyes modestly down, and while her hair is elaborately dressed, her costume is very plain.

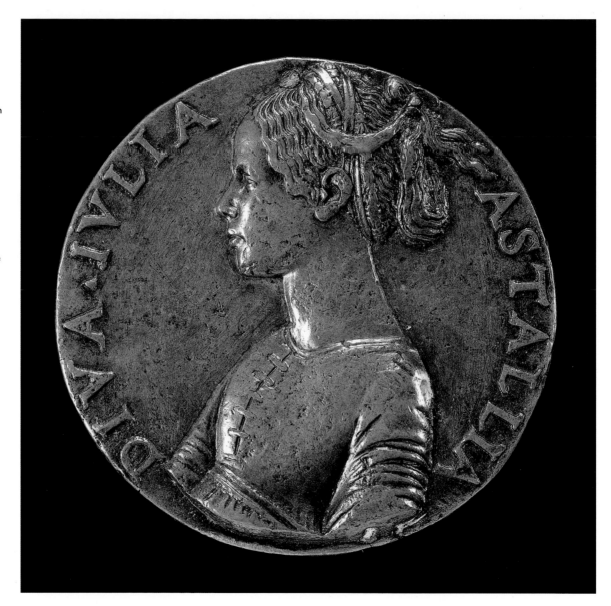

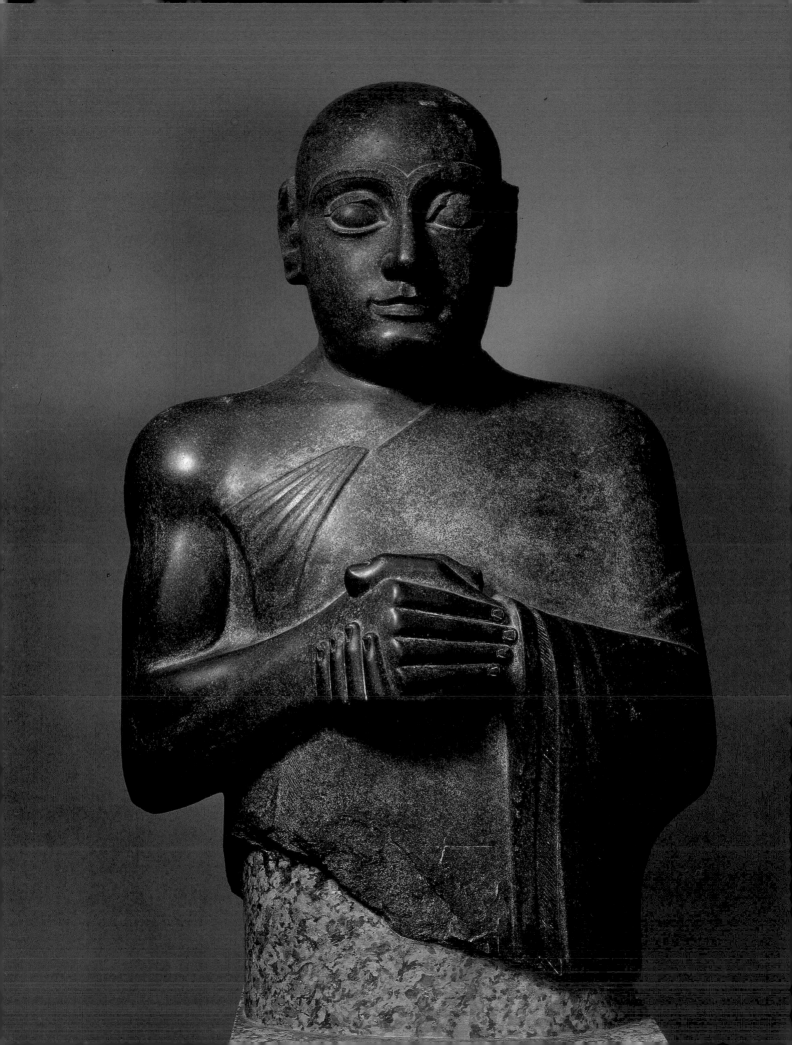

◁ **61 Head and torso of Gudea of Lagash**
Said to be from Iraq, c. 2100 BC
Black stone, 80 cm
The Sumerian king Gudea commissioned many magnificent statues of himself. Inscriptions naming him were carved on the statues, intended to promote his reputation. The statues were placed in temples at the city of Telloh, to act as perpetual reminders of his devotion to the gods. This carving belongs in the same family, with dignified features suggesting an ideal wise and devout ruler.

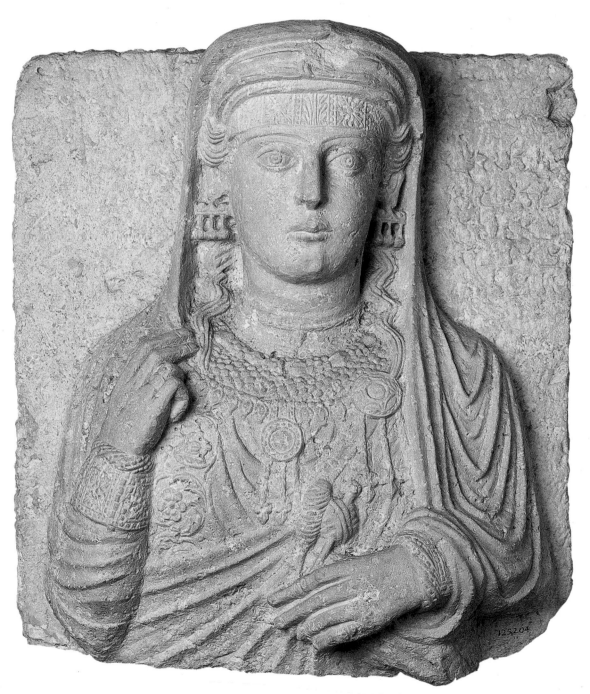

62 Memorial portrait of Tamma, daughter of Samsiqeram
Palmyra, Syria, c. AD 100–150
Limestone, 50 cm
This portrait would have been placed near Tamma's body in the cemetery at Palmyra. The merchant families of Palmyra adopted with enthusiasm the Roman traditions of individual portraiture. They displayed their wealth in life and in death: although the colours on this portrait have faded, Tamma still persuades us that she could afford the most elaborate forms of jewellery.

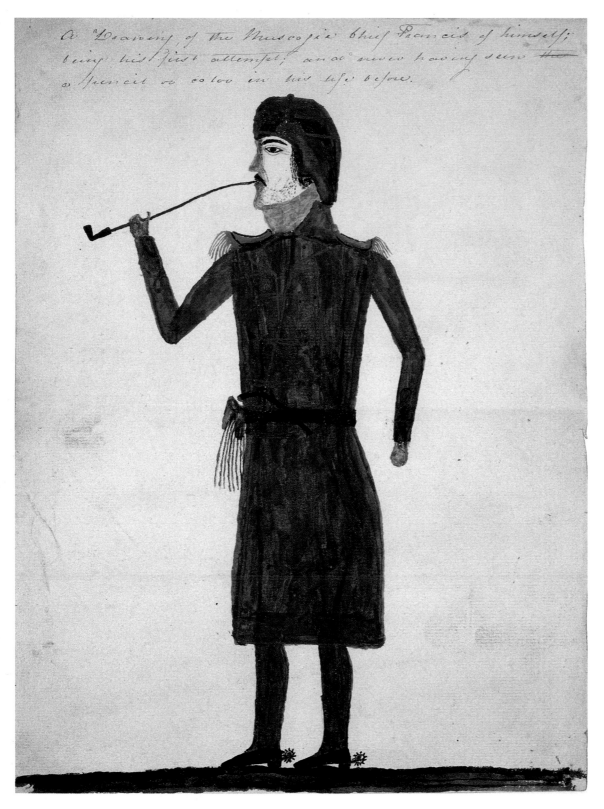

◁ **63 Self-portrait by Hilis Hadjo ('Crazy Medicine'), also called Josiah Francis (c. 1770–1818)**
Alabama/London, _c._ 1815–16
Watercolour, 28 x 20 cm
'A Drawing of the Muscojie Chief Francis of himself; being his first attempt; and never having seen a pencil or colour in his life before.'
As leader and prophet, Hadjo led the hostile Creek faction against the invasive United States during the Red Stick War 1813–15.

64 Chairman Mao statuette
Jingdezhen, Jiangxi Province, China, 1990s
Porcelain, 61 cm
The cult of Mao began in the early 1960s and propaganda figures were produced to promote the Great Proletarian Cultural Revolution, 1966–76, when he was presented as a national hero. This image from the 1990s was probably part of the revival of the Mao cult, following the 100th anniversary of his birth in 1893, which generated a new industry of Mao memorabilia.

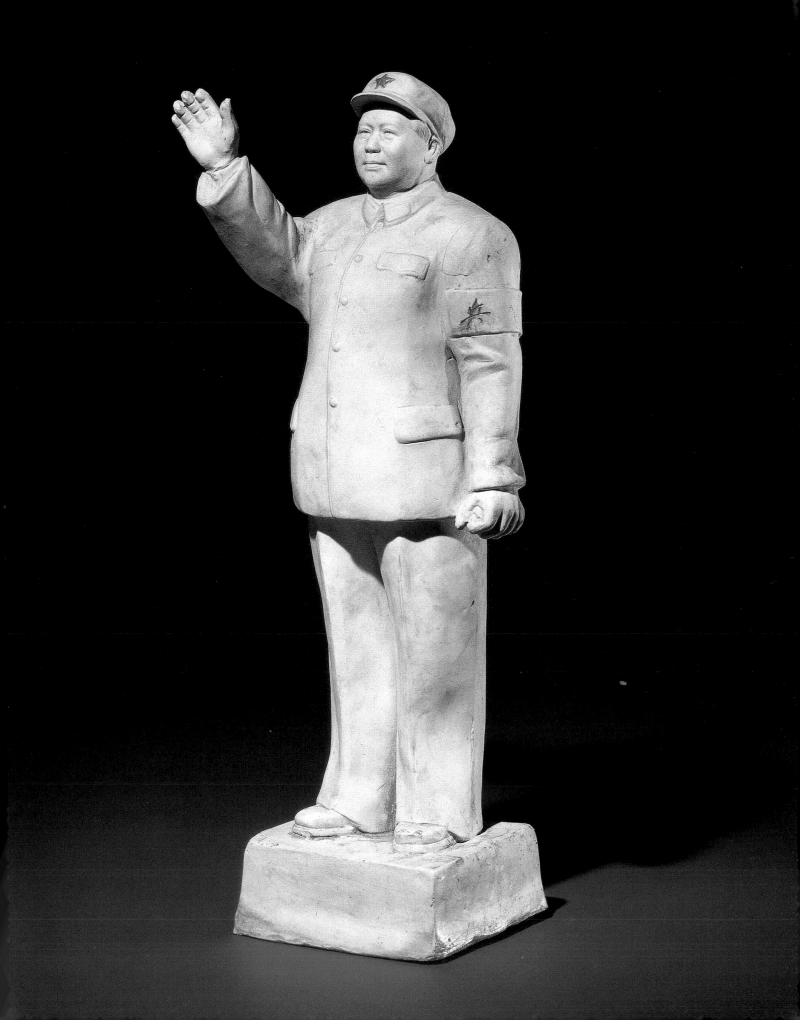

abstraction

The human form may be deduced from the most minimal details, whether radical simplification, emotionally expressive imagery or organic and geometric structures. From earliest antiquity stone has provided a material highly suitable for carving the fundamental masses of the body. The economical, elegant lines of the stone Cycladic figures from ancient Greece (fig. 72) have beguiled European artists since the beginning of the twentieth century. The Yemeni head (fig. 68), of a slightly later date, uses rather different abstract volumes and minimalist details.

Jacob Epstein, who amassed an extensive collection of non-Western sculpture, drew African figures (fig. 67). He exaggerated the facial and sexual elements of Tabwa sculpture (fig. 66), among many sources, while retaining their essential humanity. Epstein and the collections of the British Museum were of crucial importance to Henry Moore. In the mid-1930s he began to experiment with the relationship between internal and external forms in his drawing and sculpture, influenced in the example here (fig. 71) by his studies of *malagan* ancestor figures from New Ireland (fig. 70). Stella Steyn, an Irish artist who had previously studied in Paris, was confronted by a doctrinaire approach to abstraction when she briefly attended the Bauhaus in Dessau at the beginning of the 1930s. The human form was studied with a view to analyzing its essential structure and geometry, her schematic figure here (fig. 73) being one of a number of exercises she carried out as part of the basic design course on lettering.

The artists of the two contemporary medals are experimenting with the traditional form. The head on the medal by Eszter Balás (fig. 69) is used only because portraits appear on medals and not because it represents anyone in particular. This generalizing tendency is underlined by the abstract manner in which the head is treated.

**65 *Vita nuova: the criminal unlimited*
by Georgy Postnikov
(b. 1950)**
Russia, 1993
Cast bronze, diam. 9 cm
Postnikov's medal is an attack on the rise of Mafia-inspired criminal activity after Perestroika and the collapse of Communism in Russia, a wheel spinning out of control.

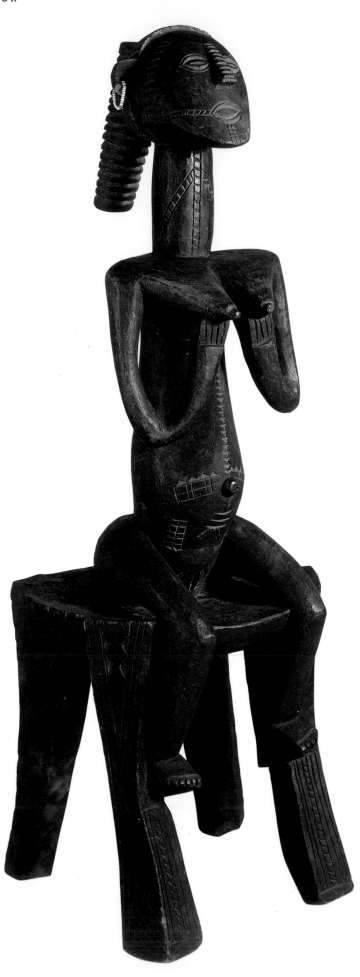

◁ **66 Tabwa seated female figure**
Democratic Republic of Congo or Tanzania,
late nineteenth century
Wood, 85 cm
The pose of the figure is very distinctively
part of the Luba tradition in which the
secrets of divine kingship are thought to
reside in a woman's breasts. The might of
Luba kingship is therefore suggested
by the attitude of this female figure seated
on a symbol of royal power.

67 Two primitive figures
by Jacob Epstein (1880–1959)
Britain, c. 1913–15
Drawing in graphite and wash,
56.1 x 41.3 cm
Epstein formed an outstanding collection
of sculpture embracing ancient Egyptian,
Cycladic, African, Oceanic, pre-Columbian
and Native North American material. After
his death some of the pieces were acquired
by the British Museum. *Two primitive figures*
resembles the figures on a wooden
mortuary post from Madagascar which
was acquired by Epstein subsequent
to the execution of this drawing.

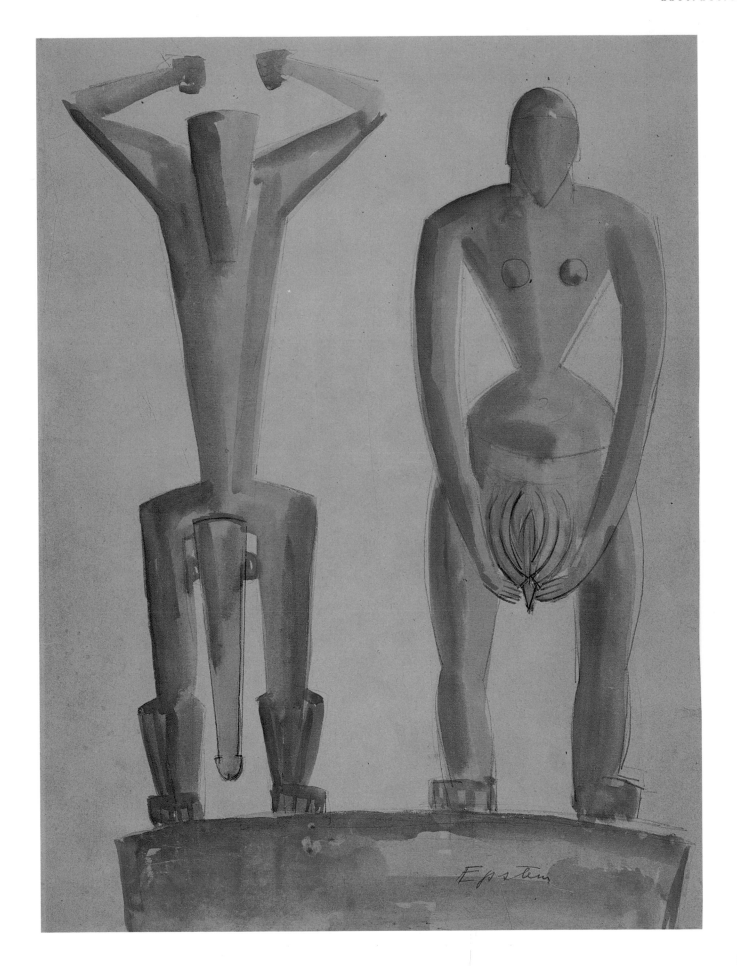

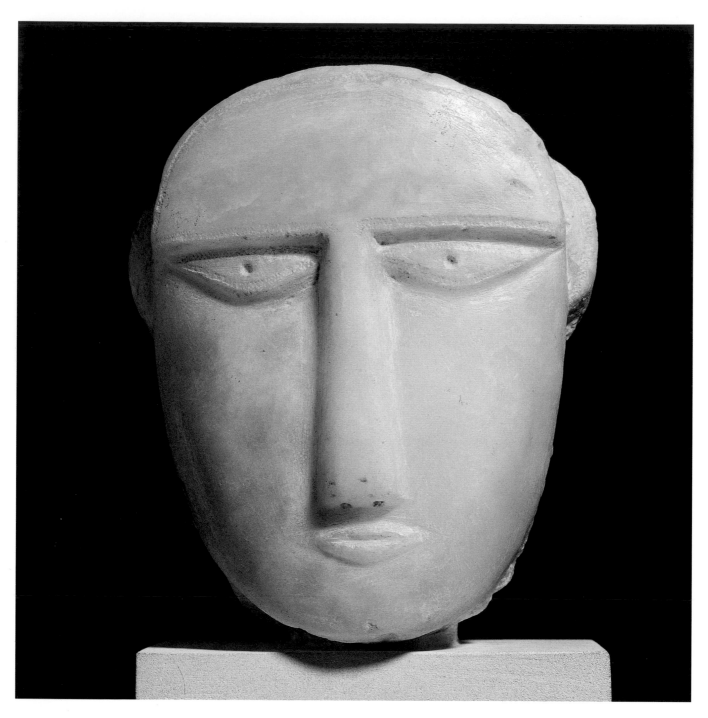

68 Grave marker
Yemen, c. 300–100 BC
Alabaster, 21.5 cm
Many graves in ancient Yemen were decorated
with an image of the dead. Sometimes these were
naturalistic and lifelike portraits, but more
traditional ones such as this aimed to catch the
essence of an individual, emphasizing only the
salient features of the human face.

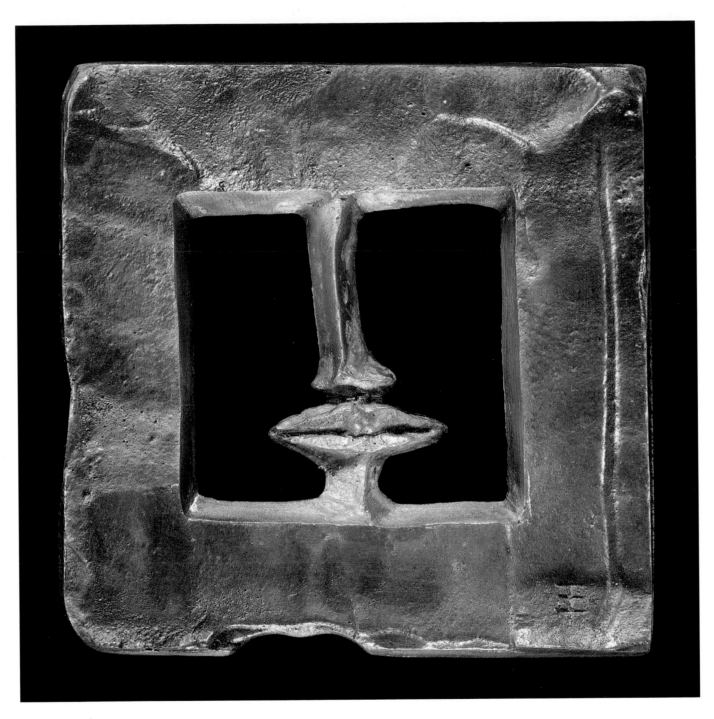

69 *Face to Face* **by Eszter Balás (b. 1947)**
Hungary, 1991
Cast bronze, 9.2 x 9 cm
Balás has chosen to rethink the conventions of the traditional
medal. This is a portrait only because portraits appear on
medals – not because it actually represents anyone in
particular. This generalizing tendency is underlined by the
abstract manner in which the head is treated.

**70 Hermaphrodite figure
made for *malagan*
mortuary ritual**
New Ireland Province, Papua
New Guinea, 1882–3
Wood, pigment and shell,
122 cm
Malagan figures are images
of a generic ancestral identity
which is capable of appearing
in human form. This carved
form is brimming with
symbolic meanings which
refer to many important
subjects including identity,
kinship, gender, death,
and the spirit world. It has
male genitalia, but female
diagnostic traits such
as the white cap. The fish
at the bottom is a rock cod,
which changes sex during
its life cycle.

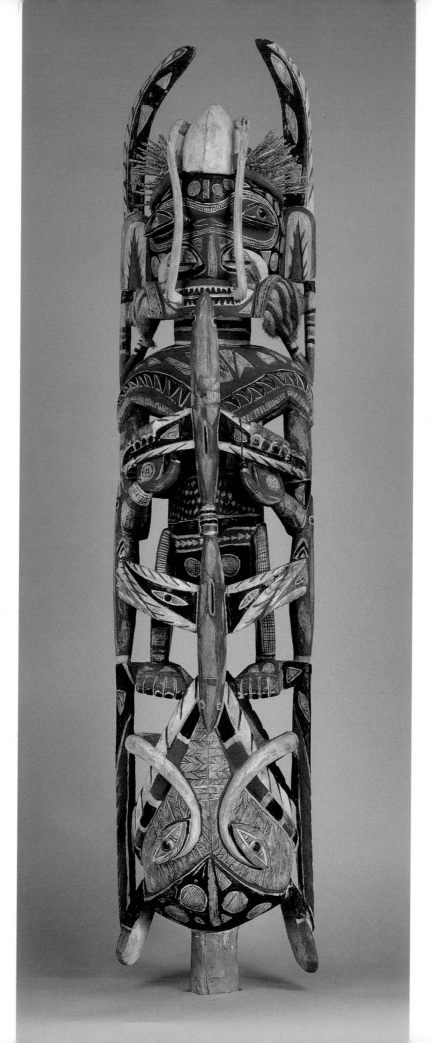

**71 *Two Women: drawing for
sculpture combining wood
and metal* by Henry Moore
(1898–1986)**
Britain, 1939
Drawing in bodycolour over
graphite, charcoal and coloured
chalks, 44.9 x 37.7 cm
Moore's interest in the
relationship between internal
and external forms emerged
in the mid-1930s, influenced
by Surrealism and, in this case,
by his studies of *malagan*
figures from New Ireland in
the British Museum.

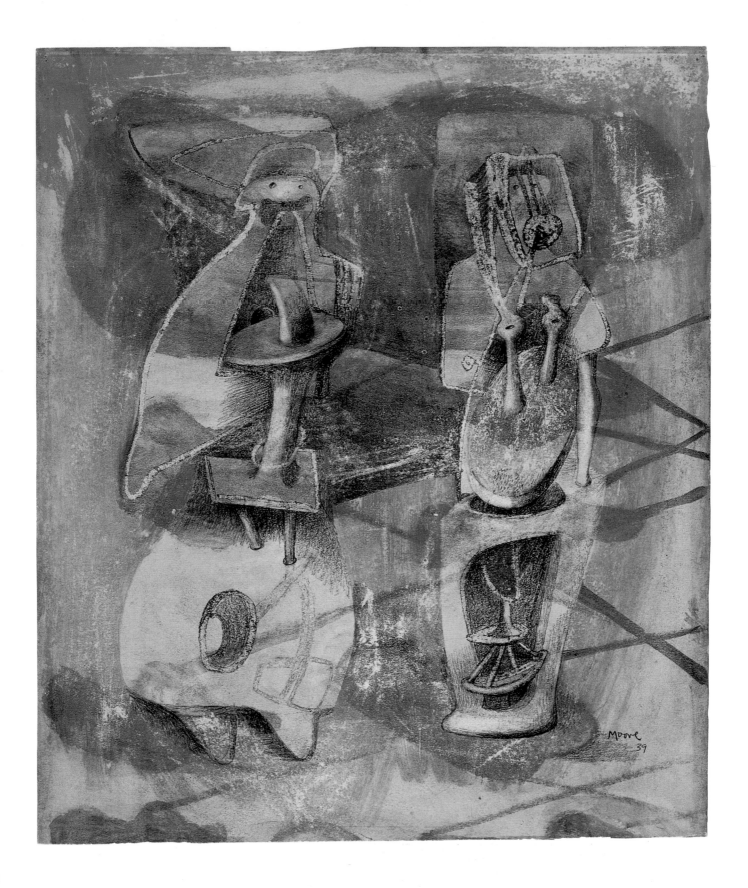

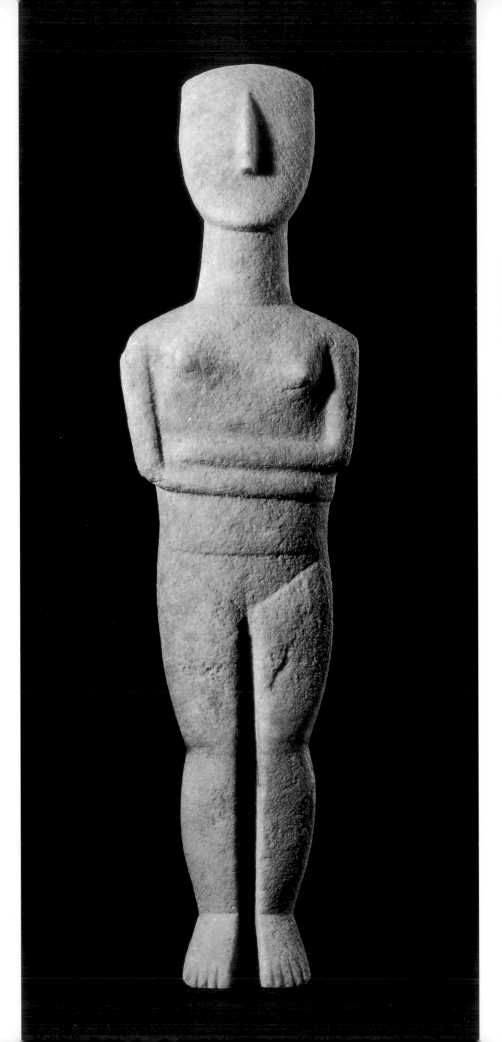

72 Cycladic figurine
Cyclades, Greece,
c. 2600–2400 BC
Marble, 49 cm
The simple elegance of
so-called Cycladic figurines
has influenced twentieth-
century sculptors and
appealed to modern tastes.
The purpose of these
sculptures is not fully
understood, except that
their discovery in tombs
naturally suggests a
funerary one. Sometimes
traces of painted decoration
survive, notably on the
face, suggesting ceremonial
or tribal markings.

73 *Schematic figure*
by Stella Steyn (1907–87)
Germany, 1930–2
Lithograph and relief print
on tissue paper, 16.7 x 7.7 cm
Stella Steyn was an Irish
artist whose friendship with
James Joyce's daughter in
Paris led to an invitation to
supply some illustrations to
Finnegan's Wake in 1929. For
one year from July 1931 she
was enrolled at the Bauhaus,
Germany's most progressive
school of art and design,
which was then situated in
Dessau. Her surviving work
from this period is related to
the course in graphic design
which she studied under
Joost Schmidt, experimenting
with typographical elements
and symbols.

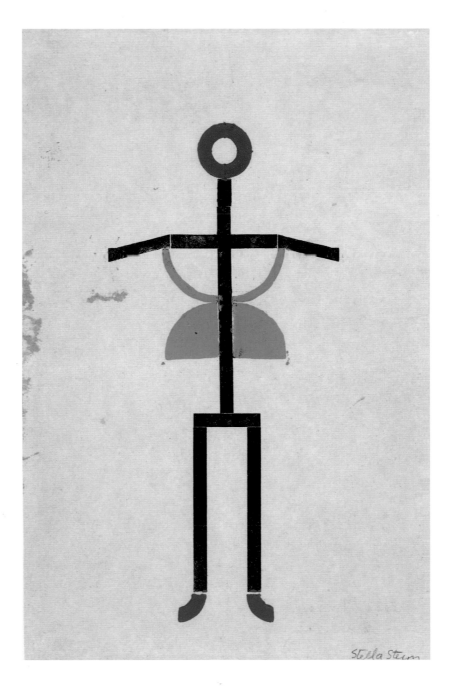

object list

CREATION

Bark painting
Coburg Peninsula (Port Essington),
northern Australia, early nineteenth
century
Bark, 59 cm
From the Haslar Hospital Museum,
Portsmouth, presented by the Admiralty;
Ethno 1967.Oc.+1

Carved figure of mother and child
(fig. 4)
Idoma, Nigeria, twentieth century
Wood, 30 cm
Ethno 1962 Af 1.1

Inupiaq arrow-shaft straightener
Alaska, nineteenth century
Mastodon ivory, 15 cm
Haslar Hospital Collection; Ethno
1855.12-20.240

10 krooni banknote
Estonia, 1940
Paper, 14.9 x 9.5 cm
CM 1984.6-5.1813

**Lamp with engraved profile
of a woman**
Courbet Cave, France, Upper Palaeolithic,
c. 10,500 BC
Limestone, 23.2 cm
PRB 1864. 2-26.1124

Maize god (fig. 2)
Maya [Structure 22, Copan], Honduras,
Classic period (AD 250–900)
Stone, 90 cm
Donated by Alfred Maudslay;
Ethno 1886-321

**Polynesian hardwood figure
known as A'a** (fig. 1)
Rurutu, Austral Islands, late eighteenth
century
Wood, 117 cm
Ethno LMS 19

Priapus (fig. 3)
Pakenham, Suffolk, first century AD
Bronze, 8.4 cm
PRB P 1990.6-1.1

**Statue of Mrs Anne Seymour
Damer (1749–1828) as the Muse
of Sculpture, modelled by Giuseppe
Cerrachi (1751–1801)**
Britain, c. 1775
Marble, 181 cm
MLA OA 10540

**Stone sculpture depicting
intercourse**
Ain Sakhri, Judaea, probably Natufian,
c. 8000 BC
Calcite, 10.4 cm
PRB 1958.10-7.1

Venus, goddess of love
From a Roman villa at Campo Iemini,
Italy, c. AD 150
Marble, 209 cm
Presented by HM King William IV;
GR 1834.3-1.1; BM Sc. 1578

***The Virgin and Child* by Raphael
(1483–1520)** (fig. 5)
Italy, c. 1512–14
Drawing in black chalk, 70.7 x 53.3 cm
PD 1894.7-21.1

***Willem Paedts as an infant, with his
nurse* by Frans van Mieris (1635–81)**
Holland, 1665
Drawing in black chalk on vellum,
29.4 x 23.3 cm
Malcolm Collection; PD 1895.9-15.1210

DEVOTION

Crystal skull (fig. 7)
Probably European, nineteenth century
Rock-crystal, 25 cm
Purchased by Mr G. F. Gunz, from Tiffany
& Co., New York; Ethno 1898-1

Folkton 'drum' (fig. 10)
Folkton, East Yorkshire, England, Late
Neolithic, c. 2600–2000 BC
Magnesian limestone, 8.7 x 10.4 cm
PRB 1893.12-28.17

Fudo Myō-Ō (fig. 13)
Japan, Heian period, late twelfth century
Wood, 144 cm
JA 1961.2-20.1

Fuller Brooch
Anglo-Saxon, late ninth century
Silver and niello, 11.4 cm
Part gift of Captain Fuller; MLA 1952,4-4,1

A Hindu ascetic
Rajasthan, Western India, late tenth
century AD
White marble, 92 cm
Given by the Brooke Sewell Fund;
OA 1964.4-13.2

**Icon of the Dormition
of the Virgin**
Byzantine, fourteenth century
Wood and pigment, 15.5 x 11 cm
MLA 1998,11-5,1

Mask of Tezcatlipoca (fig. 11)
Mixtec-Aztec, Mexico, AD 1400–1521
Turquoise and lignite mosaic over a human
skull; iron pyrite, shell, leather, 20 cm
Christy Collection; Ethno St. 401

Reliquary of St Eustace (fig. 6)
Basle, Switzerland, c. 1210
Gem-set silver-gilt, silver, wood, 32 cm
MLA 1850,11-27,1

Sculptured skull
Jericho, Palestine, late eighth millennium BC
Human skull, plaster, shell, 21 cm
WA 127414

Shaka, the historical Buddha
Japan, Edo period date in accordance with
AD 1630
Bronze, 47.5 cm
Given by Sir A.W. Franks; JA 1891.9-5.20

**Standard (*'alam*) in the shape
of the hand of Fatima**
India, nineteenth century
Tinned copper, 240 cm
Gift of Mrs Hallinan; OA 1920.7-7.1

Tara (frontispiece)
Found between Batticaloa
and Trincomalee, Sri Lanka,
eighth century AD
Gilded bronze, 1.43 m
Given by Lady Brownrigg;
OA 1830.6-12.4

Tuunraq **figure (spirit helper
to a shaman), perhaps used
as a drum handle** (fig. 9)
Yup'ik, Alaska, nineteenth century
Wood, sinew, fox teeth, 30 cm
Barrow Collection;
Ethno1855.11-26.169

Two Fish Copulating **by Sokari
Douglas Camp (b. 1958)**
Nigeria and the UK,
late twentieth century
Painted steel, feathers, 180 cm
Ethno 1996 Af 8 1

Virgin and Child (fig. 12)
Paris, France, 1320–30
Elephant ivory, 33.5 cm
Wernher Collection; MLA 1978,5-2,3

Zemí (fig. 8)
Taíno, Jamaica, AD 1200–1500
Wood and shell, 100 cm
Ethno Q77 Am 3

INSCRIPTION

Bena Lulua ancestor figure (fig. 18)
Democratic Republic of Congo,
twentieth century
Wood, 42 cm
Given by Mrs Margaret Webster-Plass;
Ethno 1956 Af 27.267

**Crescent-shaped neck ornament
(*lunula*)**
Ireland, Early Bronze Age,
c. 2300–2000 BC
Gold, 20.3 cm
PRB 1838.12-19.1

**Grotesque figure of a tattooed
woman** (fig. 20)
Said to be from Tanagra in Boeotia,
mainland Greece, *c.* 350–290 BC
Terracotta, 18.2 cm
GR 1875.3-9.9; BM Terracottas C243

Kudurru **of Marduk-nadin-ahhe**
(fig. 15)
Babylon, Iraq, *c.* 1090 BC
Black limestone, 61 cm
Presented by Sir Arnold Kemball
in 1863; WA 90841

Male figure (fig. 16)
New Zealand, mid-nineteenth century
Wood, 85 cm
Ethno Oc 1892.4-9.1

**Mask of a woman of high rank,
with labret and painted crest
design** (fig. 14)
Haida, British Columbia, *c.* 1830
Alder wood and pigment, 23 cm
Ethno 1986 Am 18.150

A Pictish warrior **by John White
(active *c.* 1575–93)** (fig. 19)
Britain, *c.* 1590
Drawing in watercolour and pen and
ink over graphite, 24.5 x 17 cm
PD 1906.5-9.1(24)

***Three Native Americans from New
York*** **by Bernard Lens (1682–1740)**
Britain, 1710
Miniature portraits in watercolour,
bodycolour and gold over graphite on
ivory, each 9 x 7 cm (oval)
PD 1840.12-12.33, 34, 35

**Water vessel with facial
scarification** (front cover
and half-title page)
Made by Mbitim, Lurangu, Sudan,
twentieth century
Terracotta, 32 cm
Given by Major and Mrs. H.P.H.Powell-
Cotton; Ethno 1934.3-8.27

The Wrestler Roshi Ensei
**by Utagawa Kuniyoshi
(1797–1861)** (fig. 17)
Japan, *c.* 1827–30
Colour woodblock print, 56 x 40.5 cm
JA 1906.12-20.01272

PERFECTION

Apollo and Diana **by Albrecht
Dürer (1471–1528)** (fig. 24)
Germany, 1501–5
Pen and ink drawing, 28.3 x 20.5 cm
PD Sloane 5218-183

Cast figure of a horn player (fig. 26)
Benin, Nigeria, sixteenth century
Brass, 62 cm
Ethno 1949 Af 49.156

Discus-thrower (*Discobolos*) (fig. 25)
From Hadrian's Villa at Tivoli, Italy,
c. AD 120–140
Marble, 170 cm
Formerly in the collection of Charles
Townley; GR 1805.7-3.43; BM Sc. 250

Dish with female head (fig. 23)
Umbria, Italy, dated 1524
Tin-glazed earthenware, diam. 43 cm
MLA 1878,12-30,970

Hindu goddess (fig. 22)
Possibly from Rajasthan, India, eleventh
century AD
Sandstone, 76 cm
Formerly owned by Sir Jacob Epstein;
OA 1962.4-20.1

**Ibibio figure from the Ekkpo
society** (fig. 27)
Old Calabar, Nigeria, nineteenth century
Wood, 180 cm
Donated by P.A. Talbot;
Ethno 1914.6-16.27

Naked female figure
Nineveh, Iraq, *c.* 1070–1060 BC
Limestone, 94 cm
WA 124963

Statue of a youth (*kouros*)
Boeotia, mainland Greece, *c.* 560 BC
Marble, 77.3 cm
GR 1878.1-20.1; BM Sc. B474

***Study for the Creation of Adam in
the Sistine Chapel*** **by Michelangelo
(1475–1564)** (fig. 21)
Italy, *c.* 1511
Drawing in red chalk, 19.3 x 25.9 cm
Given by the National Art Collections
Fund with contributions from
Sir Joseph Duveen and Henry van
den Bergh; PD 1926.10-9.1

Wood ancestor figure
Tabwa, Zambia, nineteenth century
Wood with white, red and green glass
beads, 72 cm
Presented by the Trustees of the
Wellcome Historical Medical Museum;
Ethno 1954 + 23.3540

OTHERS

**Automaton clock with Moor, dog
and globe by Carol Schmidt
(1590–1635/6)**
Augsburg, Bavaria, Germany, *c.* 1620
Gilt-brass and steel, 30 cm
Octavius Morgan Bequest, 1888;
MLA 1888,12-1,120

***A black drummer and commander
mounted on mules*** **by Rembrandt
(1606–69)** (fig. 30)
Holland, *c.* 1638
Drawing in pen, ink and wash
over red chalk, 22.9 x 17 cm
Payne Knight Bequest 1824; PD
Oo.10-122

***Black youth holding an axe
with a shrunken human head***
by Hans Burgkmair (1473–1531)
Germany, 1520s
Drawing in pen, ink and wash,
24 x 16.1 cm
PD Sloane 5218-129

Bust of the blind poet Homer
Baiae on the Bay of Naples, Italy,
second century AD
Marble, 56.6 cm
Formerly in the collection of Charles
Townley Esq.; GR 1805.7 3.85;
BM Sc. 1825

**Chinese figure with a monkey,
modelled by Johann Friedrich
Eberlein**
Meissen, Saxony, Germany, 1735
Porcelain, 15.5 cm
Bequeathed by Sir Bernard Eckstein,
Bt. 1948; MLA 1948,12-3, 64

Diogenes **by Shimomura Kanzan
(1873–1930)** (fig. 29)
Japan, 1903–5
Hanging scroll, 131.3 x 72 cm
Given by Sir William Gwynne-Evans,
Bt.; JA 1913.5-1.0585

Figure of a Polynesian pearl diver
(fig. 34)
China, Tang, early eighth century
Glazed earthenware, 30 cm
Purchased with the help of public
subscription from the George
Eumorfopoulos Collection;
OA 1936.10-12.288

**Figure of a woman in European
dress with man attached** (fig. 28)
Haida, Northwest Coast of America,
mid-nineteenth century
Argillite, 24 cm
Christy Collection; Ethno 9392

Funerary figure of King Taharqo
Nuri, Sudan, 690–664 BC
Quartzite, 52 cm
Donated by the Sudanese
Government; EA 55485

An Inuit by John White
(worked c. 1575–93)
Britain, 1577
Drawing in watercolour and pen and
ink over graphite, 22.5 x 16.3 cm
PD 1906.5-9.1(29)

A knight fighting wildmen in a wood
by Lucas Cranach the younger
(1515–86)
Germany, c. 1551
Drawing in pen, ink and wash,
18.1 x 21.8 cm
Bequeated by Mrs Rosi Schilling
through the National Art Collections
Fund; PD 1997.7-12.27

Madonna and Child (fig. 31)
Dehua, Fujian province, China,
late seventeenth to early
eighteenth century
Porcelain, 25 cm
Given by P.J. Donnelly;
OA 1980.7-28.73

**Netsuke of Dutchman
with cockerel** (fig. 33)
Japan, eighteenth century
Boxwood, 13.5 cm
JA 1945.10-17.586

Oil flask with African heads
Roman, from Bayford, Kent, England,
second century AD
Bronze, 5.4 cm
PRB 1883.12-13.300

*Portrait of three Micronesians –
Kokiuaki and his sisters,* executed
in the style of New England
portraiture by the Chinese artist
known in the West as Spoilum
(*fl.* 1770–1810) (fig. 35)
China, 1791
Oil on canvas, 100 x 65 cm
Ethnography Library, Pictorial
Collection

**Salt cellar surmounted with
the figure of the Virgin and Child**
(fig. 32)
Sherbro, Sierra Leone,
sixteenth century
Ivory, 28 cm
Ethno 1981. Af 35.1

Statuette of Hercules
Roman, found at Bavay, France,
second century AD
Bronze, 32.4 cm
Presented by Edward W.A. Drummond
Hay Esq.; GR 1834.8-1; BM Bronzes 787

POWER

Ashurnasirpal II, King of Assyria
(fig. 37)
Nimrud, Iraq, c. 865 BC
Magnesite, 106 cm
WA 118871

Baule wood figure
Ivory Coast, nineteenth century
57 cm
Given by Mrs Margaret Webster-Plass;
Ethno 1956 Af 27.30

Cast head (fig. 40)
Benin, Nigeria, fifteenth century?
Brass, 23 cm
Ethno 1897.12-17.3

**Coronation medal of Ghazi-ud-
din Haider, the Nawab of Awadh**
Lucknow, India, AD 1819
Gold, 6.5 cm
Given by Henry van den Bergh;
CM 1921.5-3.1

Denarius of Tiberius, Roman
emperor (AD 14–37)
Rome
Silver, 1.9 cm
CM BMC 34

**Kuba-Bushoong figure
commemorating King
MishaaPelyeeng aNce** (fig. 41)
Democratic Republic of Congo,
probably late eighteenth century
Wood, 54 cm
Emil Torday Collection;
Ethno 1909.5-13.2

**Kwakwaka'wakw potlatch
welcome figure**
British Columbia, nineteenth century
Red cedar wood, with traces of
painting, 270 cm
Ethno 1949 Am 22.238

**Medal of Elizabeth I, Queen of
England and Ireland (1533–1603)
by Nicholas Hilliard
(c.1537–1619)** (fig. 39)
England, c. 1580–90
Cast and chased gold, 5.6 x 4.4 cm
CM M6903

**Medal of Sultan Mehmet II
(1430–81) by Bertoldo di Giovanni
(d. 1491)**
Italy, 1480
Cast bronze, 9.2 cm
Given by Henry van den Bergh,
through the National Arts Collection
Fund; CM 1919.10-1.1

Nebamun hunting in the marshes
Thebes, Egypt, c. 1390 BC
Wall painting, 83 x 98 cm
EA 37977

A Retired Townsman (fig. 42)
Japan, Edo period, seventeenth
to eighteenth century
Wood and painted crystal, 42.5 cm
Given by Sir A.W. Franks;
JA 1985.12-27.98

**50 rials banknote showing
Shah's head**
Iran, 1971
Paper, 7.1 x 14.2 cm
CM 1984.6-5.2282

**50 rials banknote showing
Shah's head obliterated**
Iran, 1979
Paper, 6.9 x 13.6 cm
CM 1983.2-31.9

Sceptre
Sutton Hoo, Mound 1, Suffolk, England
Anglo-Saxon, first quarter
of seventh century
Stone, iron and copper-alloy, 82 cm
Gift of Mrs Edith M. Pretty;
MLA 1939,10-10,160 and 205

Statue of Prince Khaemwaset
Abydos, Egypt, c. 1250 BC
Sandstone conglomerate, 138 cm
Donated by Samuel Sharpe; EA 947

Temple lintel (16) (fig. 38)
Maya, Yaxchilan, Mexico, Classic period
(AD 250–900)
Limestone, 76.2 cm
Donated by Alfred Maudslay; Ethno
1886-318

**Yoruba door carved in low relief
with scenes of hunting, warfare
and domesticity**
Nigeria, twentieth century
Wood, 257 cm
Donated by the Trustees of the
Wellcome Historical Medical Museum;
Ethno 1954 Af 23.208a-c

**Yoruba house post carved with
woman and child** (fig. 36)
Nigeria, twentieth century
Wood, 180 cm
Ethno 1949 Af 46.147

DRAPERY

Courtesan by Kaigetsudō Anchi
(fig. 44)
Japan, c. 1710–20
Woodblock print, 59 x 32 cm
JA 1910.4-18.0175

**Figure of dead shaman prepared
for burial by Simeon Stilthda
(c. 1800–89)** (fig. 48)
Haida, Northwest Coast of America,
nineteenth century
Painted wood, 60 cm
Presented by Mrs Harry Beasley;
Ethno1944 Am 2.131

Jahangir in private audience
India, Mughal period, c. 1610 AD
Gouache on paper, 15.5 x 6.21 cm
Stowe Collection; OA 1920.9-17.02

Sea nymph, 'Nereid' (fig. 47)
From a monumental tomb erected
at Xanthos in Lycia, now south-west
Turkey, c. 400 BC
Marble, 140 cm
GR 1848.10-20.81; BM Sc. 909

Seated woman in a taffeta dress by
Henri Matisse (1869–1954) (fig. 45)
France, 1938
Charcoal drawing, 65.8 x 50.3 cm
PD 1979.12-15.17

Standing Buddha (fig. 46)
Takht-i Bahi, north-west Pakistan,
first century AD
Schist, 100 x 30.2 cm
OA 1899.7-15.1

Statue of King Nectanebo I
(fig. 49)
Saft el-Hinna, Egypt, c. 370 BC
Black granodiorite, 155 cm
EA 1013

*Study of drapery for the figure
of Christ by Fra Bartolommeo
(1472–1517)* (fig. 43)
Italy, 1499
Brush drawing on linen, 30.5 x 21.2 cm
Malcolm Collection; PD 1895.9-15.487

A young woman with field glasses
by Hilaire Germain Edgar Degas
(1834–1917)
France, c. 1868
Brush drawing with chalk,
27.9 x 22.4 cm
Mange de Hauke Bequest;
PD 1968.2-10.26

GUARDIANS

BRITANNIA GROUP:

Sestertius of Antoninus Pius, Roman emperor (AD 138–161)
Mint of Rome, AD 140–4
Brass, 3.2 cm
CM 1872.7-9.631

Tetradrachm of Lysimachus, king of Thrace (305–281 BC)
Mint of Alexandria Troas
Silver, 3 cm
CM Payne Knight B16

Two penny coin of George III (1760–1820)
Great Britain, 1797
Copper, 4 cm
CM BMC 1065; CM 1928.8-17.540

10 shilling Treasury note
Great Britain, 1922
Paper, 7.7 x 13.5 cm
CM 1980.11-35.3

Five pound Bank of England note
Great Britain, 1961
Paper, 9 x 15.8 cm
CM 1980.3-46.21

Britannia
England, Staffordshire,
Longton Hall factory, c. 1750
Porcelain, 39 cm
Franks Collection;
MLA Porcelain Cat.1.18

Ceremonial cosmetic palette
Egypt, 3250–3100 BC
Grey siltstone, 28 cm
EA 20791

Chess-pieces of a knight and warder
Probably Scandinavian,
mid-twelfth century
From a hoard found on the Isle of
Lewis in 1831
Walrus ivory, 10.5 cm
MLA 1831,11-1,114 and 116

European soldier
Benin, Nigeria, eighteenth century?
Brass, 35 cm
Ethno 1928.1-12.1

Flemish shield (fig. 53)
Flanders or Burgundy,
late fifteenth century
Wood, 83 cm
Gift of Revd J. Wilson; MLA 1863,5-1,1

Imagawa Yoshimoto by Tsukioka
Yoshitoshi (1839–92) (fig. 56)
Japan, c. 1870s–80s
Brush drawing, 55.9 x 40.6 cm
JA 1990.6-14.01(19)

Low relief wall-panel depicting royal bodyguards (fig. 55)
Nineveh, Iraq, c. 700 BC
Alabaster, 160 cm
WA 124901

Memorial brass of a knight
England, 1506
Brass, 69.5 cm
MLA 1861,3-4,1

Painted warrior vessel (fig. 52)
Moche, Peru, AD 250–550
Pottery, 22.5 cm
Christy Collection, donated
by A W Franks; Ethno P. 1

Shield depicting human figure (fig. 54)
Central Solomon Islands, early
nineteenth century
Plaited cane, shell, and vegetable putty,
87 cm
Presented by the Trustees of the
Wellcome Historical Medical Museum;
Ethno 1954 Oc 6.197

Statue of Isis protecting Osiris (fig. 51)
Thebes, Egypt, c. 580 BC
Grey siltstone, 81.3 cm
EA 1162

Temple figure (fig. 50)
Hawai'i, 1790–1810
Wood, 272 cm
Presented by W. Howard;
Ethno 1839.4-26.8

Warrior in a winged helmet by
Leonardo da Vinci (1452–1519)
(fig. 57)
Italy, c. 1475–80
Drawing in metalpoint on prepared
paper, 28.7 x 21.1 cm
Malcolm Collection; PD 1895.9-15.474 1

Warrior 2 by Geoffrey Clarke
(b.1924)
France, 1956
Etching, 97.4 x 60 cm
PD 1990.3-3.37

PORTRAITS

Bust of Sir John Wyndham Pope-Hennessy CBE, FBA (1913–94) by Dame Elisabeth Frink DBE, RA (1930–93)
Britain, modelled 1975
Bronze, 42.4 cm (inc. plinth)
MLA 1977,6-3,1

Chairman Mao statuette (fig. 64)
Jingdezhen, Jiangxi Province, China,
1990s
Porcelain, 61 cm
Given by Gordon Barrass;
OA 1998.10-6.1

Head and torso of Gudea of Lagash (fig. 61)
Said to be from Iraq, c. 2100 BC
Black stone, 80 cm
Presented by the National Art
Collections Fund in 1931; WA 122910

Jion Daishi
Japan, early fourteenth century
Hanging scroll painting, 167.5 x 85.5 cm
JA 1964.7-11.010 (Japanese Painting
ADD 377)

Memorial portrait of Tamma, daughter of Samsiqeram (fig. 62)
Palmyra, Syria, c. AD 100–150
Limestone, 50 cm
WA 125204

Mummy portrait of a woman (fig. 58)
Hawara, Fayyum, Egypt, AD 100–120
Encaustic on limewood, 38.2 cm
Transferred from the National Gallery;
EA 74706

Portrait medal of Federigo da Montefeltro, Duke of Urbino by Sperandio da Mantova (b. 1425–8, d. after 1504)
Italy, c. 1482
Cast bronze, diam. 9 cm
CM George III.VP 2

Portrait medal of Giulia Astallia (fig. 60)
Mantua, c. 1480–90
Cast bronze, diam. 6.4 cm
CM George III. IP. 24

Portrait medal of Leonora Cambi by Bombarda (fl. 1540–75)
Italy, c. 1560
Cast bronze, diam. 6.9 cm
CM 1933.11-12.46

Portrait medal of Martin de Hanna by Leone Leoni (c. 1509–90)
Italy, 1544 or 1546
Cast bronze, diam. 7.1 cm
CM George III. IP 437

Portrait of Benjamin Franklin (1706–90)
Etruria, Staffordshire, England,
Wedgwood and Bentley, 1779
Jasperware, 33.5 cm
Franks Collection; MLA Pottery Cat.1.73

Portrait of an unknown woman by Rogier van der Weyden
(c. 1400–64) (fig. 59)
Flanders, c. 1430–40
Drawing in metalpoint on prepared
paper, 16.6 x 11.6 cm
PD 1874.8-8.2266

Portrait of Xia Zhenyi
Chen Yuan (mid-fourteenth century AD)
Hanging scroll, ink and colours on silk,
122 x 44 cm
OA 1881.12-10.013

Self Portrait by Gustave Courbet
(1819–77)
France, 1852
Black chalk with charcoal, 57 x 45 cm
Given by the National Art Collections
Fund, Samuel Courtauld and other
subscribers; PD 1925.7-11.1

Self-portrait by Hilis Hadjo ('Crazy Medicine'), also called Josiah Francis (c. 1770–1818) (fig. 63)
Alabama/London, c. 1815–16
Watercolour, 28 x 20 cm
Ethnography Library, Pictorial
Collection

ABSTRACTION

Abstract female figure
Said to be from Turkey, c. 2300–2100 BC
Stone, 20 cm
WA 134630

And then she made the lasses, O by Hazel White (b. 1965)
Great Britain, 1996
Cast bronze, 8.2 x 6.8 cm
CM 1998.10-12.4

Bronze Age warrior
Said to be from Syria/Palestine,
c. 2000–1750 BC
Bronze, 23.7 cm
WA 105149

Cycladic figurine (fig. 72)
Cyclades, Greece, *c.* 2600–2400 BC
Marble, 49 cm
GR 1863.2-13.1; BM Sc. A17

Face to Face
by Eszter Balás (b. 1947) (fig. 69)
Hungary, 1991
Cast bronze, 9.2 x 9 cm
CM 1992.12-24.1

Female figure
Egypt, fifth millennium BC
Ivory and lapis-lazuli, 11.4 cm
EA 32141

Figure (*Yipwon*)
Arambak people, Upper Karawari
River, East Sepik Province, Papua New
Guinea, late twentieth century
Wood with red pigmentation,
237.5 cm
Ethno 1976 Oc 15.1

Grave marker (fig. 68)
Yemen, *c.* 300–100 BC
Alabaster, 21.5 cm
Presented by Lt Com. C. Craufurd in
1924; WA 116674

Hermaphrodite figure made for
malagan mortuary ritual (fig. 70)
New Ireland Province, Papua New
Guinea, 1882–3
Wood, pigment and shell, 122 cm
Presented by the Duke of Bedford
1884; Ethno 1884.7-28.49

Hunting walrus **by Parr**
(1893–1969)
Nunavut, Canada, 1960s
Ink (felt tip pens) on paper, 50 x 65 cm
Ethnography Library, Pictorial
Collection

Jug painted with a scene
of mourning
Athens, *c.* 720–700 BC
Pottery, 44.3 cm
GR 1912.5-22.1

Painted bowl
Talli Bakun, Iran,
late fifth millennium BC
Pottery, 15.8 cm
WA 128622

Painted figure, Mexico
Tala-Tonalá style, Jalisco,
200 BC–AD 250
Pottery, 23 cm
Heaven Collection; Ethno Hn 22

Portrait **by János Kalmár (b.1952)**
Hungary, 1991
Cast bronze, 10.4 x 9.8 cm
CM 1991.10-17.1

Schematic figure
by Stella Steyn (1907–87) (fig. 73)
Germany, 1930–2
Lithograph and relief print on tissue
paper, 16.7 x 7.7 cm
PD 1975.4-12.3

Seated figurine
Vinca, Serbia, Neolithic, *c.* 4600–4300 BC
Terracotta, 17 cm
PRB 1939.7-4.1

Stater
Britain, early first century BC
Gold, diam. 1.8 cm
BMC 6

Stater
North-east Gaul, end of second
century BC
Gold, diam. 2.5 cm
BMC 1104

Stater **in the name of Philip II**
of Macedon
Late fourth century BC
Gold, diam. 1.8 cm
CM Bank 1132

Study for 'Les Demoiselles
d'Avignon' **by Pablo Ruiz Picasso**
(1881–1973)
France, 1906–7
Drawing in bodycolour and
watercolour, 62.6 x 46 cm
Purchased with a contribution from
the National Art Collections Fund;
PD 1996.2-16.3

Tabwa seated female figure
(fig. 66)
Democratic Republic of Congo
or Tanzania, late nineteenth century
Wood, 85 cm
Wellcome Collection;
Ethno 1954+23.3539

Tool with engraved figure
of a woman
Montastruc, France, Upper Palaeolithic
c. 10,500 BC
Reindeer antler, 12.8 x 4 cm
Christy Collection; PRB Sieveking 566

Tsuki-no-Hikari **(Moonlight)**
by Igor Mitoraj
Pietrasanta, Italy, 1991
Bronze, 350 cm

Two primitive figures **by Jacob**
Epstein (1880–1959) (fig. 67)
Britain, *c.* 1913–15
Drawing in graphite and wash,
56.1 x 41.3 cm
PD 1980.11-8.4

Two Women: drawing for sculpture
combining wood and metal **by**
Henry Moore (1898–1986) (fig. 71)
Britain, 1939
Drawing in bodycolour over graphite,
charcoal and coloured chalks,
44.9 x 37.7 cm
Accepted by HM Government in lieu
of tax on the estate of Lord Clark of
Saltwood and allocated to the British
Museum; PD 1988.3-5.5

Vita nuova: the criminal unlimited
by Georgy Postnikov (b. 1950)
(fig. 65)
Russia, 1993
Cast bronze, diam. 9 cm
CM 1997.4-4.1